MIXED MEDIA
in clay

Techniques for **CLAY, PLASTER, RESIN** and **MORE**

Darlene Olivia McElroy & **Patricia Chapman**

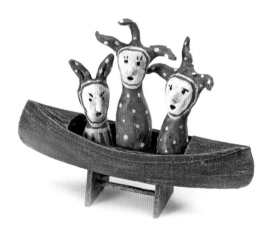

NORTH LIGHT BOOKS

Cincinnati, Ohio
CreateMixedMedia.com

CONTENTS

TOOLS AND MATERIALS USED IN THE TECHNIQUES IN THIS BOOK

For easy reference, the opening page of each chapter in this book includes a comprehensive list of all tools and materials used in that chapter. Don't feel like you have to acquire all of these products at once. The techniques and projects in this book can be mixed and matched to use what you have.

← (ON PREVIOUS PAGE)
THE NAVIGATORS ▪ PATRICIA CHAPMAN
Hand-modeled Critter Clay painted with acrylic paint and found object wooden boat.

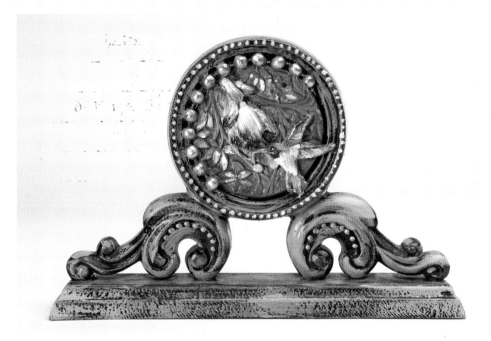

← **MY GARDEN FRIEND** ▪
DARLENE OLIVIA MCELROY
Reference chapters: Molding Putty and Paper Clay

↓ **SEGRETO** ▪
DARLENE OLIVIA MCELROY
Reference chapters: Paper Clay and Plastic Modeling Pellets & Strips

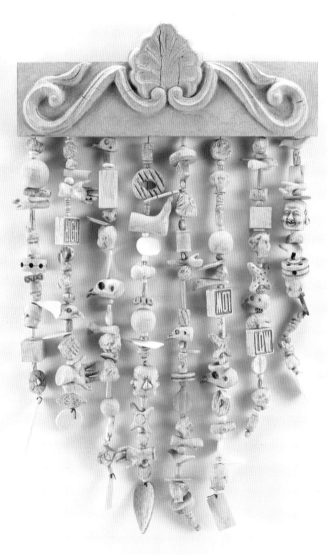

WANT MORE?

Visit **CreateMixedMedia.com/Mixed-Media-in-Clay** for bonus project demonstrations of the art featured on this page.

↑ **BEADED CURTAIN** ▪ PATRICIA CHAPMAN
Reference chapters: 3-D Casting and Critter Clay

Most of us have fond childhood memories of getting gloriously dirty while playing in the mud. Well, it's time to get your hands dirty again! This book will help you rediscover the joy of creating with clay and clay alternatives—most unexpected—and the vast variety of techniques unique to each.

In this book we delve into the possibilities of using traditional clay in nontraditional ways, and we have assembled a wide array of materials with clay-like properties that you can transform into anything from jewelry components to larger scale sculptures, or use as collage elements or textural backgrounds. This is the perfect way to add more "mix" to your mixed-media art.

Some of you may be asking, "What do plaster, resin, fiber paste and plastics have to do with clay?" It is our intention with this book to wander as far outside the traditional-clay box as we can. All of the mediums we explore have a couple of characteristics in common though. None of them need to be baked or fired in a kiln, and each of them transforms from

a malleable substance to a solid form. Some act exactly like clay while others have adhesive qualities or metallic properties. We show you some ways to explore the different clay alternatives, but we leave it up to you to make them your own.

Since we are continually being asked how to cast objects, we explain different kinds of casting as well as hand-built and found-object armatures. Most of these techniques are incredibly easy and, of course, we will tell you which materials work best with the different casting and molding techniques presented.

Whether you are intrigued with the idea of adding surface texture to your painted canvas surfaces or constructing freestanding sculptures combining found objects and a variety of different mediums, you will find a boatload of inspiration here and plenty of new ideas, information and techniques to play with. We will introduce you to clay alternatives you may never have heard of and techniques and ways to use these mediums you may never have thought of.

Come clay with us—

—Darlene & Patricia

WANT MORE?

Visit **CreateMixedMedia.com/Mixed-Media-in-Clay** for bonus project demonstrations of the art featured on this page.

→ **EVERYTHING IS COMING UP ROSES** ▪ PATRICIA CHAPMAN
Reference chapters: Resin Clay, Plaster of Paris & Plaster Gauze, 3-D Casting

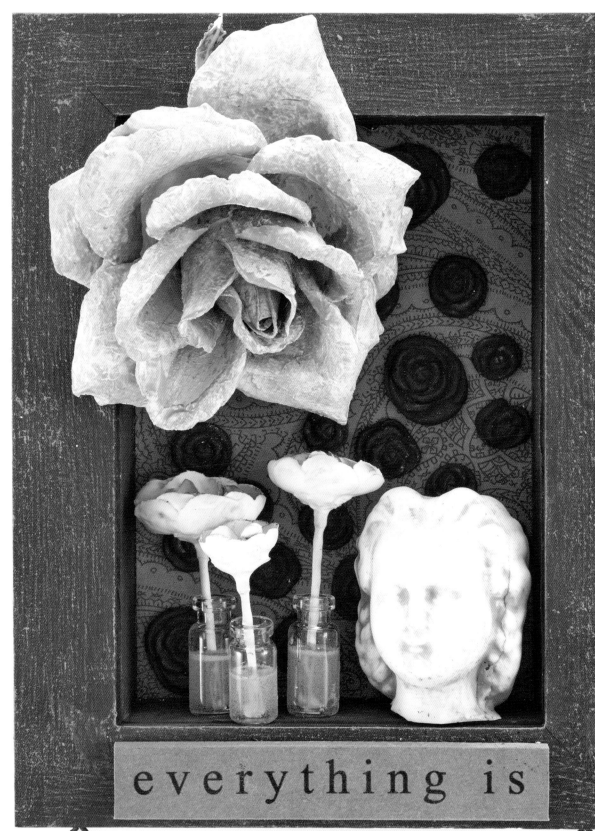

everything is

coming up roses

TYPES OF CLAY & CLAY ALTERNATIVES

What comes to mind when you think about clay? Mud? Earth? Pottery? Heavy? Sticky? Yes, traditional clay is all of the above. But do you think of plaster, plastic, resin or paper mache? Probably not. What these clay alternatives have in common with traditional clay is that they start out in a malleable form and end up solid. So let's take a tour of the different forms of traditional and nontraditional clays we will be exploring in this book.

TRADITIONAL CLAY

This is the natural earthen clay that is typically yellow, red or gray in color and can be purchased in blocks. Traditionally clay is shaped into forms using hand building by slab or coil, sculpting, slip casting or throwing on a potter's wheel, and it is fired at a high temperature in a kiln that removes all moisture content and transforms the shaped clay body into a permanent structure. Unlike the premium air-dry clays, traditional clay is very brittle and fragile in its bone-dry, unfired state. Since this book is a "no kilns allowed" zone, we will show you how to utilize this most traditional and basic of materials in completely nontraditional ways.

CRITTER CLAY

There are several different brands of air-dry clay on the market, but what they all have in common is the fact that all you will need is time and air to transform them from their flexible to their solid forms. In this book we will be using Critter Clay made by Aves Studio, which is a premium and very durable air-dry clay that can be used in any way you would use traditional clay. But unlike bisque-fired traditional clay, this self-hardening clay can be drilled or sanded after it cures. About the only disadvantage is that it is not waterproof and must be finished with a waterproof sealer if you want it to be waterproof. It accepts any kind of paint or finish beautifully.

PAPERCLAY

In this book we are using Creative Paperclay. This lightweight air-hardening material is an extremely versatile clay alternative. In its moist form, it can be molded, shaped and used to cover armatures. This nontoxic material, composed of all-natural ingredients, is great for creating dolls, vessels, jewelry, relief images or sculpture. It has good self-adhesive properties and once it has dried it can be painted with any type of paint or finish. And of course, like all the clays we use in this book, it needs no baking or firing.

EPOXY RESIN CLAY

Two-part epoxy resin clay is becoming a more widely known art and craft medium. It has several unique advantages in the world of clay alternatives. We are using Apoxie Sculpt made by Aves Studio, which comes in a variety of colors, but you can create your own custom colors either by mixing existing colors or by kneading acrylic paint into the clay. Sculpt will harden in a few hours but takes 24 hours to fully cure to its rock-hard, final state. After kneading together equal amounts of the two components of resin clay, you get a sticky, thick putty that will adhere itself to anything except a silicone or Teflon surface. Used just as an adhesive, resin clay is indispensable, but it can also be used with press molds, as a modeling and sculpting material, to create jewelry elements or collage and assemblage embellishments and as a base for bead or other small object mosaics.

CLAYSHAY

Traditional clay can be purchased in a powdered form, but after you mix it with water to form a clay, it has none of the advantages of the powdered ClayShay made by Aves Studio. ClayShay is a powdered clay/paper mache hybrid. It can be mixed to a thin consistency to use as a casting medium. Mixed to a slightly thicker consistency, it can be spread over and will self-adhere to any slightly roughed, nonslick surface or armature. Mixed to a very thick claylike consistency, it can be shaped and molded. All this versatility comes with minimal shrinkage, maximal durability and the option to be drilled, sanded, carved and painted after it sets.

PAPER MACHE

As a clay substitute, paper mache is remarkable. In its powdered paper form, it already contains an adhesive that allows it to stick to any roughened or porous surface. It is particularly effective used over Styrofoam shapes. After it is spread over the surface of your choice, it can be smoothed with a wet finger and either stamped or embellished with any textural marks you can think of. After it dries it can be sanded, painted, drilled or carved, and it is extremely lightweight and durable.

READY-MIX JOINT COMPOUND

Also known as drywall compound or mud, this inexpensive white substance is used primarily in building construction. Ready-mix lightweight joint compound is a premade form of joint compound designed for fast application and easy maintenance. The compound is a complex combination often including water, limestone, expanded perlite, acetate polymer and other ingredients. The delicate mixture of compounds gives it a creamy texture that spreads easily and hardens as the moisture evaporates. It is great for backgrounds and adding texture to surfaces.

PLASTER AND PLASTER CLOTH

As a casting medium, plaster offers almost instant gratification. Setup time is remarkably rapid. Plaster is easy to mix and inexpensive, and it has a look very similar to white porcelain. Dip almost any object in a plaster soup and you will completely change the character of that object. An old shoe dipped in plaster becomes a "porcelain" art object.

Plaster cloth (or gauze) comes in strips of an open-weave cloth impregnated with plaster. After plaster cloth is dipped in water, it has the amazing ability to conform to any shape you smooth it onto. When the plaster cloth sets, it can be lifted from the form and it will retain the shape of that form. Both plaster and plaster cloth can be painted with any kind of paint.

VENETIAN PLASTER

Venetian plaster is a wall and ceiling finish consisting of plaster mixed with marble dust and applied in thin, multiple layers, which are then burnished to create a smooth surface with the illusion of depth and texture. When left unburnished, Venetian plaster has a matte finish that is rough and stone-like to the touch. It can be colored with acrylic paint and other colorants.

FIBER PASTE

This paste by Golden dries to the appearance of rough handmade paper. Skimming the product with a wet palette knife can make a smoother surface. When dry, it has an off-white color and is very absorbent, making it ideal for use with acrylic and watercolor washes or inks. It can also be colored with acrylic paint or inks before using. It can be sewn, shaped, embossed or used with a stencil.

PLASTIC MODELING PELLETS AND STRIPS

We are using Friendly Plastic pellets and strips made by Amaco. The pellets are small, milky white, tiny beads that become clear and totally malleable when they are heated either in hot water or on a nonstick electric skillet or with a heat gun. They can be mixed in their melted state with a variety of different mediums to create color or accents, and they can be painted with acrylic paint after cooling. Plastic pellets are an extremely versatile modeling medium. Since the pellets hold their form after cooling, they can be used for sculptural modeling or with silicone press molds. They also make great beads and mixed-media art embellishments. Rolled into a slab, the softened pellets can be stamped with any texture, and if you are not pleased with your results with any of these procedures, just remelt them and start over!

Plastic designer strips are lightweight and flexible and come in a wide variety of shimmery metallic colors. The strips can be softened easily in hot water, on a nonstick electric skillet or with a heat gun. Using a variety of techniques, they can be shaped, molded, stamped, fused, cut, layered, melted into silicone molds or rolled. Combined with decorative paper, beads, wire or other embellishments, this is a wonderful medium for creating jewelry or mixed-media art components.

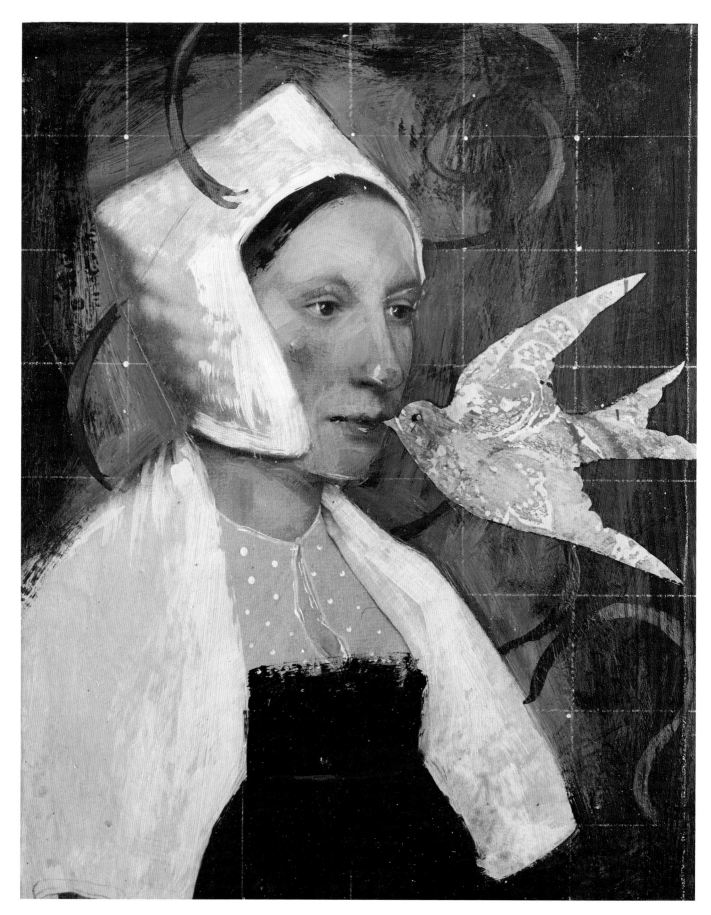

DREAM KISS ▪ DARLENE OLIVIA MCELROY
Bird cut out from clay monoprint and glued on painting with soft gel.

CLAY MONOPRINTS 1

Who knew you could accomplish so many different looks with ceramic clay without ever using a kiln! Using clay as our printing surface, we will be making marks, applying paint in a variety of ways, layering prints, printing on different substrates and using metallic paint for sparkle. The beauty of this technique is that you are not limited to the size of your clay printing plate, the clay can be cut into shapes, and the clay cleans up easily and can be reused at a later date as long as you don't let it harden. This is a super art technique for all levels of artists and for all ages.

MATERIALS USED IN THIS CHAPTER:

acrylic craft paint

brayer

butcher paper or plastic

ceramic (traditional) clay, white and groutless

Golden Open acrylic paints

lightweight papers and fabric

mark-making tools

paper towels

rolling pin

sponge brushes

water in spray bottle

MAKING MONOPRINTS

Create monoprints without the hassles of cleanup and a printing press with an affordable, groutless white clay from a ceramic or clay studio. It's as simple as rolling out your clay and making marks in it using a knife, pencil or clay tools. Working on wet clay, add your paint, then pull a print using paper, fabric or wallpaper. Your marks/painting will be flipped when printed. Practice printing different kinds of marks before trying something complex.

Layer prints for fun or if the original print is dull or you just don't like it. Different color layering, paint viscosity and brayer pressure will affect the print, so play around.

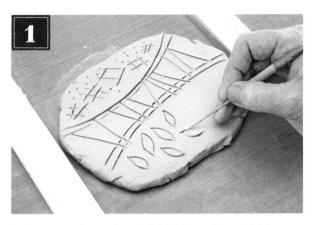

Roll out your clay until it is ¼"–½" (6mm–13mm) thick. Carve a design into the clay. Trim for straight edges if desired.

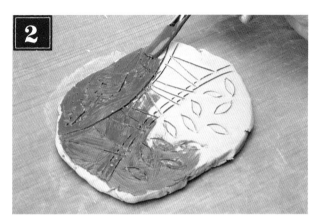

Apply paint to the higher areas as this is what prints.

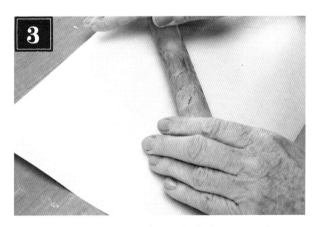

Layer your paper over your clay and roll a brayer or roller to get a good print.

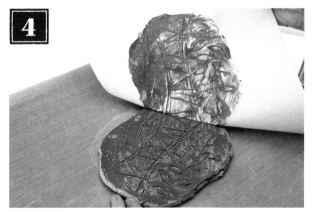

Remove the paper by gently pulling it off the clay.

TROUBLESHOOTING TIPS

- If your marks are too light you will have a hard time pulling off a good print. You may want to start with a test print with different marks and depths.

- If the print is too gushy, you used too much paint. If you can't get a print, you may have let the paint get too dry before printing.

MONOPRINTING TIPS

- Prints vary with various types of paper, pressure and paint viscosity.

- The possible mark-making tools are endless. Stamps and texture plates pressed into clay are another option.

- You can get much finer lines on your print by carving into the clay.

- You can paint the clay first before carving into it.

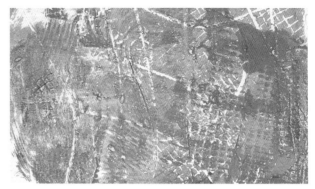

Paper that has three layers of printing on it.

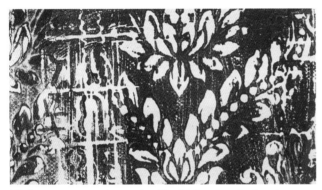

Wallpaper stamped into clay. The high points in the clay are painted and then the clay is printed.

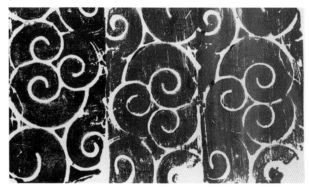

Each time you print the clay, it flattens the design. Notice the line quality change here.

Layered prints on painted paper.

Multiple prints overlapping.

Cut up monoprint collaged on top of another monoprint.

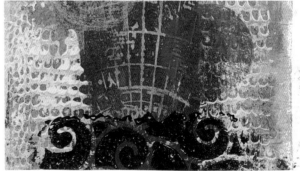

Stamp on clay plate and stamp on finished art.

STICKINESS SOLUTIONS

Moist clay may stick to your print along with the paint. If this happens, either let it dry and then brush the dried clay off, or coat it with polymer medium matte if you want to keep it on your surface. This only works with small amounts of clay, not big chunks. If you let your clay get leather hard (stiffened but still slightly damp), the clay won't stick to the print, but the clay will not be reusable in the future.

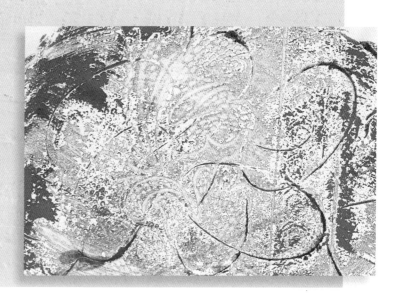

MAKING A FAUX WOODCUT

Unless you want to use oil-based paints, which are another animal altogether, with this technique, try Open acrylics by Golden, which have a longer drying time than regular acrylics. Carve a design into ½" (13mm) leather-hard clay (clay that has stiffened but is still slightly damp). Roll on your paint, lay your paper over it and brayer, then pull off your print. You may want to do some test prints first to get the feel of the paint viscosity and the paper.

Faux woodcuts can be printed on paper or fabric.

MONOPRINTS AS COLLAGE ELEMENTS

Monoprints can become a patterned paper to collage onto your art to create a textured art element or as a recognizable but stylized cutout. Make a number of patterned backgrounds ahead of time and have them available to you when you need something wonderful to collage on your art.

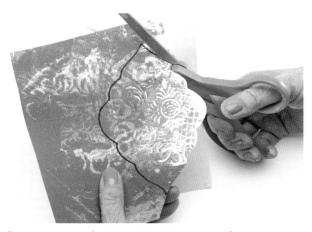

Draw or trace a shape on your monoprint and cut.

Apply with soft gel to art for patterned elements.

ADDING EFFECTS TO MONOPRINTS

You can end up with a finished monoprint, or you can keep adding to the piece with stencilling, glazing, drips and collage.

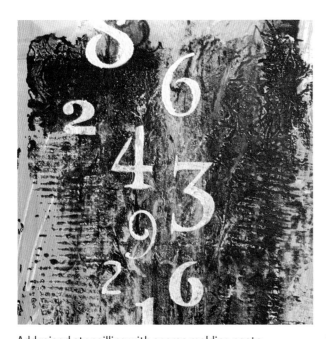

Add raised stencilling with coarse molding paste.

Apply stripes of tinted glaze.

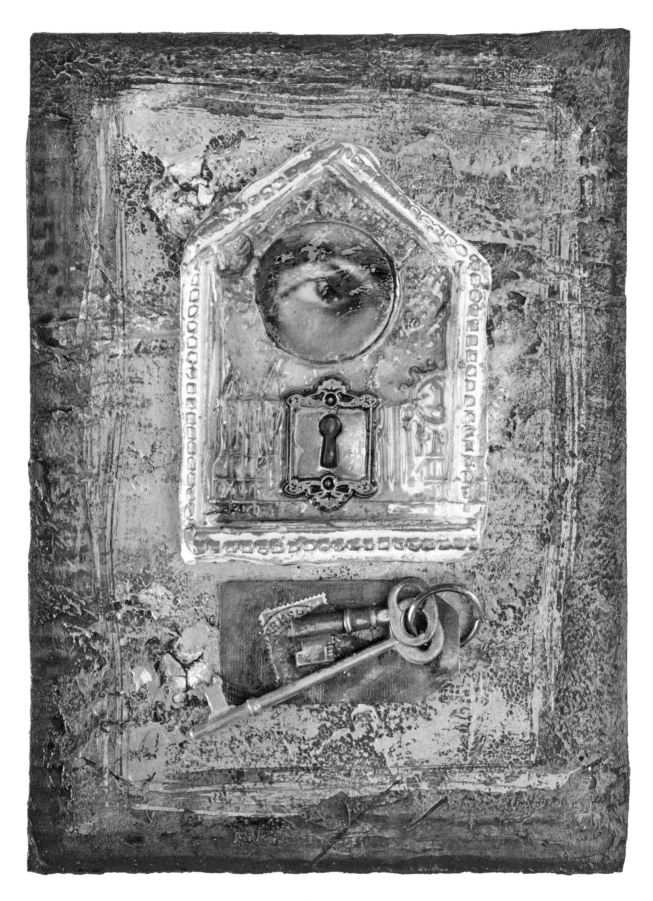

MYSTERY BEHIND THE KEYHOLE ▪ DARLENE OLIVIA MCELROY
Painted and collage-cast embossed window shape glued on background with E6000.

CLAY CASTING ②

Remember how much fun we had making plaster of Paris hand casts for our parents as children? This is the grown-up version of that. And it still is tons of fun! There are multiple ways to cast with clay and they are all great ways to add dimension to your art. Each of these casting materials gives you a different look and feel:

Plaster of Paris—This creates a soft, chalky cast. It takes paint well and you can give it a hard surface with GAC 800 or a resin coating. Drying time is approximately 20–30 minutes, and the clay mold can be reused if stored properly.

Resin—This creates a very hard surface but is somewhat toxic, so work in a well-ventilated area with a mask. The resin can be tinted with resin colors prior to pouring. Some resins come precolored. Resin takes approximately 15 minutes to set up. Clay molds are unable to be reused after casting with resin.

Fiber Paste by Golden—This has a flexible, handmade paper feel when dry. Drying time may be as long as a day. The fiber paste gives you more flexibility because it can be bent, folded, sewn and stapled. It can be made into sculptural shapes and it takes paints extremely well. The clay mold cannot be reused after casting.

MATERIALS USED IN THIS CHAPTER:

acrylic paint

brushes

cardboard box

carving tools

ceramic (traditional) clay

cooking spray

fiber paste

Kinetic Sand

knife and straight edge

palette knife

plaster of Paris

plastic wrap

polymer medium

resin (Amazing Casting Resin)

toothbrush

optional: colored encaustics

optional: GAC 800

CASTING TIPS

- Your marks/painting will be flipped when printed.

- Work in a well-ventilated area when working with resin.

MAKING A MOLD TO CAST WITH

Make marks in the clay for your mold by carving or stamping. Just remember that the deepest marks you make in the clay surface will create the highest relief on your cast piece. When satisfied with your design, trim the clay into a square or rectangle with additional cuts for the walls of your dam (the edges that will hold in your casting medium).

Use your clay mold before the clay hardens so you will be able to peel the clay off after the plaster sets.

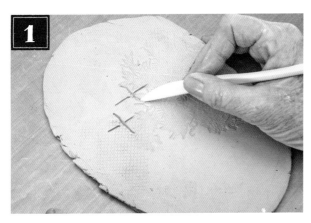

Carve a design into the clay.

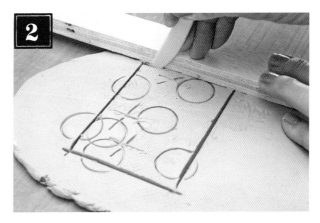

Trim your designed clay into a rectangle or square..

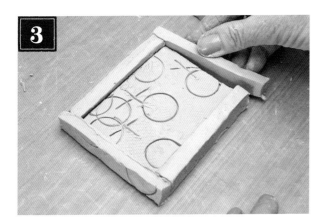

Create the walls of your dam by cutting clay strips ½" (13mm) thick and ½" (13mm) taller than the center piece. To help the walls adhere to the main piece, wet and score where they meet.

POURING

Another way to make a mold would be to cut out the bottom of a small cardboard box and embed it in the marked clay slab. Then, pour the plaster and peel the cardboard off after the plaster has set up.

CASTING WITH PLASTER OF PARIS

Once cast, plaster is easy to paint, trim and sand. Plaster of Paris is white, so if you paint it and it chips, the white will show. However, adding tempera or fluid acrylics to the plaster when you are mixing it with water will create a colored plaster. Sealing with GAC 800 or resin will also prevent chipping.

Mix the plaster according to the manufacturer's instructions. If adding tempera paints or acrylics, add cool water, as it slows down the setup time and allows you time to mix the plaster well. After the plaster has cured, put any removed clay into a plastic bag with a little water so you can reuse it later.

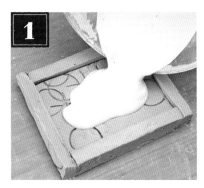

Pour plaster of Paris into the clay mold. Then wait at least 30 minutes. You might place aluminum foil underneath in case of leaks.

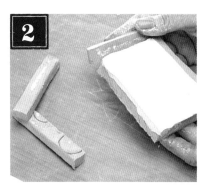

Pull away the clay walls once the plaster has hardened.

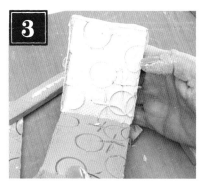

Peel the clay off to reveal the richly textured plaster cast.

SANDING

If the edges of your piece are not straight or smooth, you can sand them with a Dremel tool, a band saw, sandpaper or even your concrete driveway. Anything that works, right?

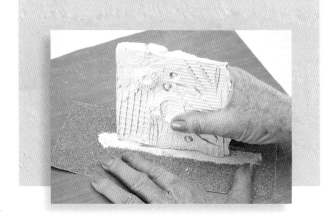

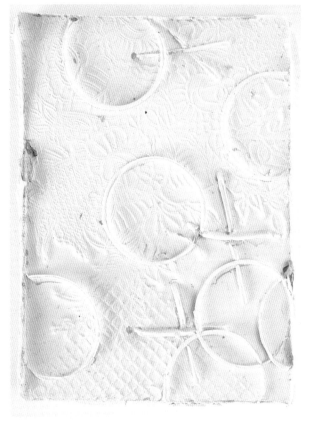

CASTING SMALL OBJECTS USING CLAY

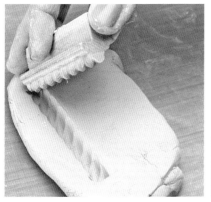

Another option is to press small objects into clay, pour plaster into the resulting shape, and remove the casting after the plaster has cured.

ADDING FINISHES

Before painting the plaster with acrylics, coat it with polymer medium to seal it. When done, a coat of GAC 800 or resin will give it a hard and shiny surface. Another option is to color it with encaustics. This will give your art a cloudy, waxy finish. In this case, you do not need to seal the surface as encaustics do not stick to nonporous surfaces.

Plaster with colored encaustics (added after casting) gives it a matte look.

Coat with GAC 800 or resin for hardness.

CASTING SMALL OBJECTS USING KINETIC SAND

Do you have a small toy, china doll, frame edging or piece of jewelry you want to cast? Press it into Kinetic Sand, making sure the sand is deep enough to get a good cast. Then pour your plaster into the mold, and let it set up as you have done previously. (Kinetic Sand comes in a variety of colors; we are using pink sand for this demonstration.)

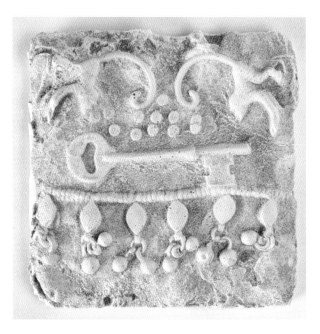

TINTING

Remember that you can tint the plaster when mixing. Fluid or high-flow acrylics work best, and the warmer the water you mix with your plaster the faster it sets up.

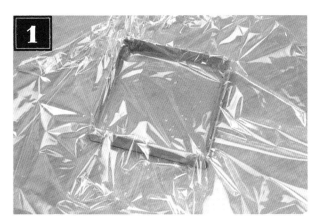

1 Line a small box or lid with plastic wrap.

2 Press Kinetic Sand in the box and smooth to a flat surface.

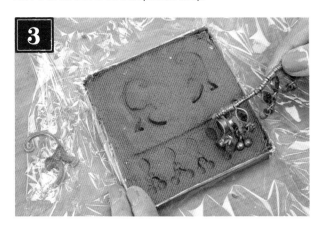

3 Press objects firmly into the clay. Gently lift objects, being careful to maintain impressions.

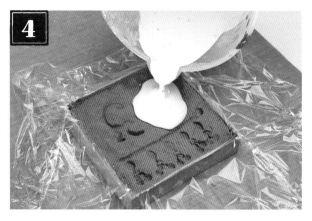

4 Pour plaster into the box. When the plaster is cured, remove the casting. Remove any excess sand with a toothbrush.

CASTING
WITH RESIN

Instead of using plaster, you can pour resin in your clay mold. This will give you a very hard cast image.

Following the manufacturer's instructions for the resin, pour the resin mixture into your textured clay dam. It will set up in approximately 6 minutes, and you can pull the clay mold off the resin. This clay is not reusable. The resin can be colored but when curing in the clay mold, some of the clay color will be absorbed into the resin. You may find that you like the back side of the resin piece as much as the textured front side. You can also paint it with acrylic paint.

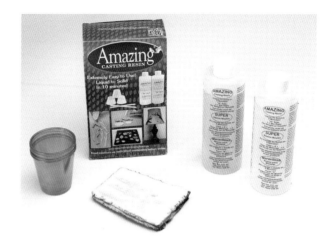

Please note that there are different types of resin; some are toxic and others are less so. Be sure to follow all safety precautions including working in a well-ventilated area and wearing disposable gloves if recommended.

As the resin cures, the clay colors it. (Shown: the back side of a cast.)

Cast resin with a Red Oxide stain added.

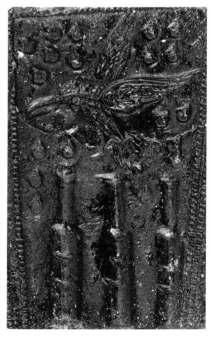

Cast resin sprayed black.

CASTING WITH FIBER PASTE

Fiber paste is great for making flexible casts that can be shaped, cut with scissors or even sewn. This results in an archival acrylic skin that has the feel of handmade paper. It can be painted with acrylics after casting, or the paste can be tinted before casting. You can use this as your piece of art, a collage element or to make pages if you are a book artist. If you are unsure if it is totally dry, lift an edge to test. Wait until it lifts off easily. You will not be able to reuse the clay after use. It may take 24 hours to dry.

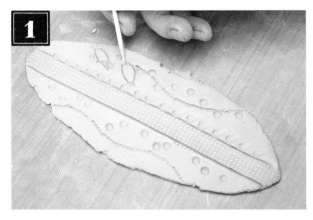

Spray cooking spray on leather-hard or dry clay that has been carved. Wipe off any excess oil.

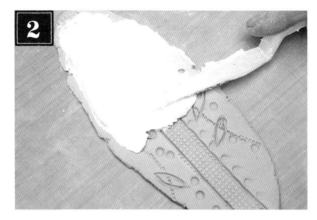

Spread fiber paste over the clay and let it dry. When dry, pull off the clay.

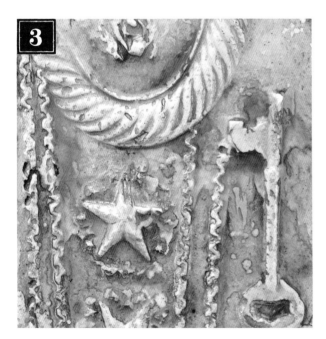

Paint, metal leaf or color rub can be applied to castings once the fiber paste has dried and been removed from the clay.

Another option is to color it with encaustics.

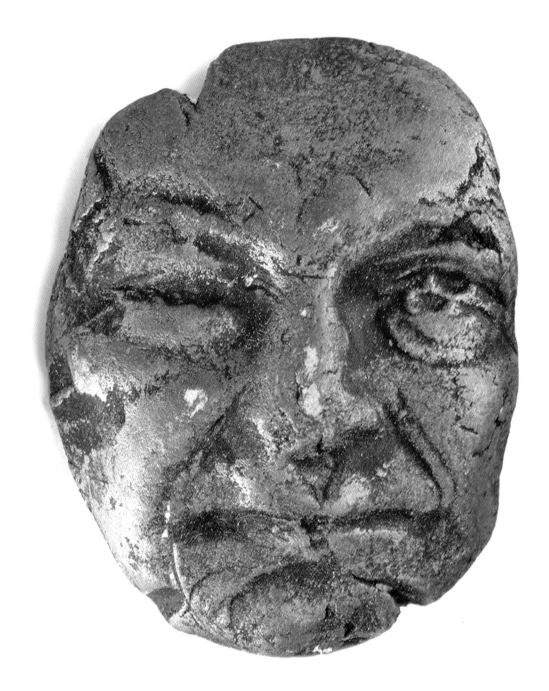

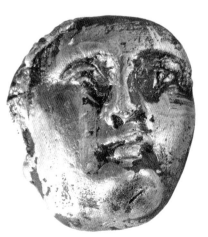

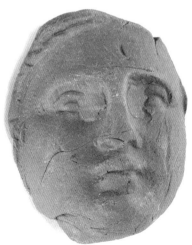

CLASSICAL CAST FACES ▪
DARLENE OLIVIA MCELROY
Top face: ClayShay (powdered clay), Burnt Umber paint with gold rub.
Left face: Paperclay, gold leaf and stain.
Right face: Critter Clay, natural.

MOLDING PUTTY ③

After making your first mold with this amazing product, you are going to want to make molds of everything. Seashells, bracelets, manhole covers—the possibilities are endless. If you have something too precious to glue to your art, make a mold of it and cast it in the variety of ways shown in this book. Carry this product with you at all times, as you never know when the mood will strike to cast something you see.

Once you have made your mold, try casting with the following: paperclay, resin clay, fiber paste, soft or hard gel, modeling (molding) paste and pumice gel. This may take some experimenting on your part. The ones mentioned (with the exception of resin clay) can all be trimmed once they are cured or dried.

······································

MATERIALS USED IN THIS CHAPTER:

acrylic paint

Amazing Mold Putty or Ranger Melt Art Mold-n-Pour

baby oil

clear silicone caulk

cornstarch

disposable gloves

fiber paste

heavy book

paper plate

rolling pin

small object to be molded

textured objects

wax paper

MAKING A PUTTY MOLD

Amazing Mold Putty and Ranger Melt Art Mold-n-Pour are both two-part molding compounds. Take two equal amounts of Part A and Part B (enough to make your mold) and knead them together until mixed thoroughly.

Place on your textured object and wait approximately 15 minutes; the putty should feel rubbery by then. Peel off the mold and you are ready to start making your molded objects. This technique works best with lower relief objects (1" depth or less).

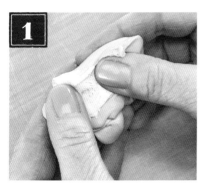

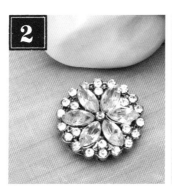

Following the manufacturer's instructions, take equal parts of A and B and mix thoroughly.

Place the mixed putty on your object, pressing around its form. Let it sit for at least 15 minutes.

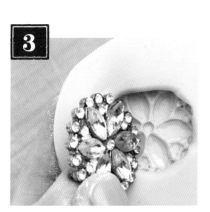

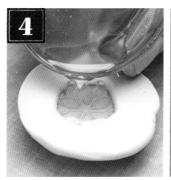

Once the putty feels rubbery, peel it off your object and it is then ready to use.

You can also mold other materials such as molding paste and resin (shown here). Place resin (or clay or clay alternative) into the mold and remove it when dry or cured. The object can be trimmed wet or when dried.

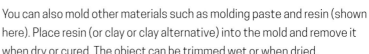
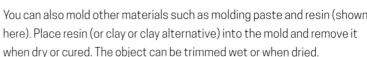

MOLDING PUTTY TROUBLESHOOTING

If the molding putty is not mixed thoroughly, it will not set up.

Sign up for our FREE e-newsletter at CreateMixedMedia.com.

PUTTY MOLDS OF LARGE, FLAT OR UNUSUAL SHAPES

You can also make molds with the putty using low-textured items like beading or a textured collage. After making the mold, place fiber paste on the mold, rolling it with a rolling pin to make sure it is flat, not lumpy. This requires less sanding later. When one side is dry, put it between wax paper with a heavy book on top so it will not warp while drying. The drying time is longer but worth it. If it has warped, try soaking it in water and gently try to flatten it. Too much pressure and not enough wetness may cause it to crack.

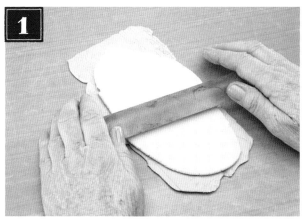

Place fiber paste on the putty mold, then roll over it until the paste is smooth and flat.

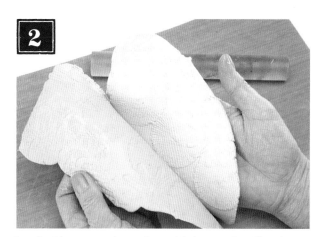

Let the fiber paste dry on the mold, then peel it off and paint.

Shown is a large mold (middle) made from Indian beadwork (left). A fiber paste flower (right) was made from the mold. The finished cast was painted brown with gold rub added.

MAKING HOMEMADE MOLDING PUTTY

MOLDING PUTTY RECIPE

¼ cup (59ml) 100% silicone caulk
½ cup (118ml) cornstarch
¼ tsp. (1ml) acrylic paint
½ tsp. (2ml) baby oil

Measure out the silicone caulk onto a paper plate. Add cornstarch, paint and baby oil and mix together, kneading until the mixture is no longer sticky. Add additional cornstarch if it still sticks.

Make your own molding putty for a fraction of the cost of the store-bought putty. Mix 100-percent clear silicone caulking with cornstarch, a little acrylic paint and baby oil to create flexible molds with incredible detail. You can use these molds with casting resin, paper mache, air-dry clay or resin clay to create an infinite number of duplicates of your favorite small objects. Work in a well-ventilated area and wear disposable gloves.

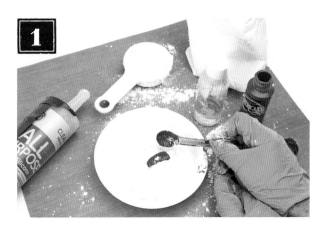

Mix a batch of homemade putty following the recipe provided.

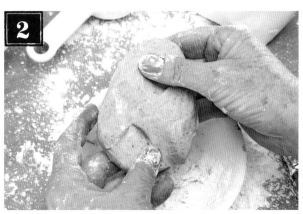

Knead until the mixture is no longer sticky, adding more cornstarch as needed.

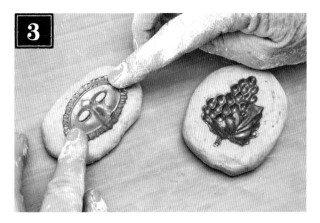

Measure out enough homemade putty to fit a small object, press the object into the putty, and allow the putty to set up with the object embedded (about 15 minutes). Then remove the object and make a replica with the casting medium of your choice.

MOLDING WITH HOT GLUE

Out of molding putty and can't get to the store to buy some or get what you need to make your own? Bring out your hot glue gun and small, slick objects made of metal, glass or ceramic. Put a glob of hot glue on a silicone or heavy plastic sheet and place your object facedown in it. When cool, pull the glue off the object. Start by loosening all the edges and don't be afraid to give it a hard yank to release it. If you didn't have enough glue, you might find a hole when you lift the object out; just lightly touch up the back of the mold with more hot glue.

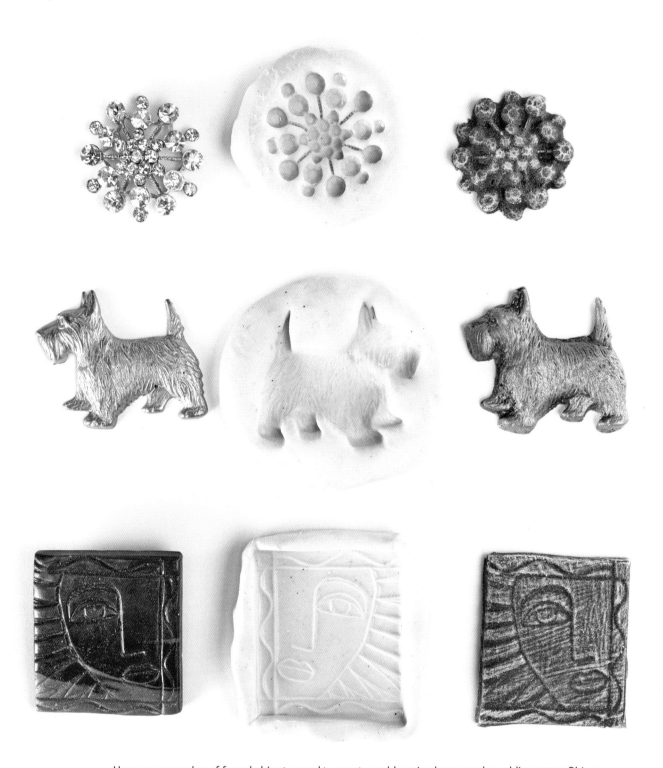

Here are examples of found objects used to create molds using homemade molding putty. Objects used are a rhinestone starburst, brass metal charm of a dog and wooden brooch with an etched design. Since these objects do not have much depth (1" depth or less), they are perfect for creating small molds using molding putty. These pieces were cast with Amazing Casting Resin and painted, but you can use resin clay, paper mache, plaster, paperclay or ClayShay for casts as well. Use these pieces as embellishments in your collage and mixed-media creations or as jewelry components.

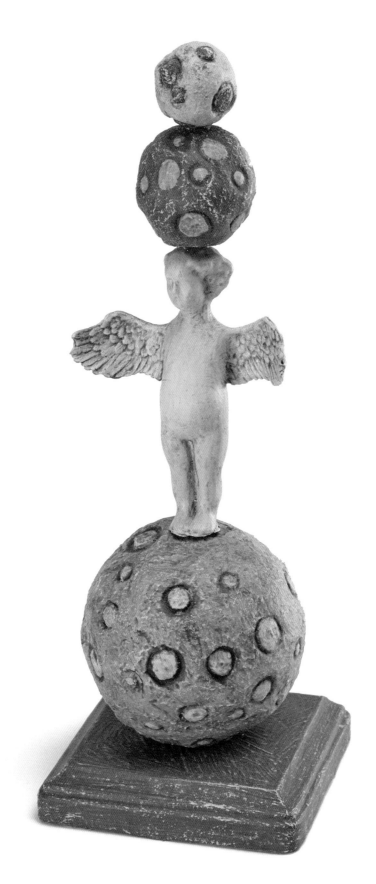

BALANCING ACT ▪ PATRICIA CHAPMAN
3-D cast resin pieces, paper mache covered, stamped and painted Styrofoam balls, wood base.

3-D CASTING ④

With this simple 3-D casting technique, you can easily create one-piece block molds. Using silicone RTV (room temperature vulcanization), you can make fully dimensional, flexible molds with fantastic detail that can be used to cast objects dozens of times. You can cast in resin, plaster or powdered clay like Clayshay. We prefer the resin because of its durability, but they all are fun to make. You will need an object with a base large enough to adhere to the bottom of your mold box that will also be large enough to pour the casting material into.

MATERIALS USED IN THIS CHAPTER:

5-minute epoxy gel

Alumilite High Strength 3 silicone mold making rubber

Amazing Goop

ClayShay, resin or plaster (Amazing Casting Resin used here)

craft knife

masking tape

object to mold

plastic cup for mixing

posterboard

MAKING A MOLD TO CAST WITH

If you have objects you wish you could replicate, why not try a simple one-piece block mold made from liquid silicone? Unlike the silicone press molds that make duplicates with a flat back, the block mold made with liquid silicone will create a mold of three-dimensional objects. You can make countless duplicates of your favorite doll heads or figures to use in your mixed-media art.

Choose an object with a base and nothing projecting out and downward (known as undercuts). The mold will take overnight to cure completely, but once it is cured, you can pour fast-setting resin, plaster or thinly mixed ClayShay into your mold, and finish your casts with any paint, wash or patina you like.

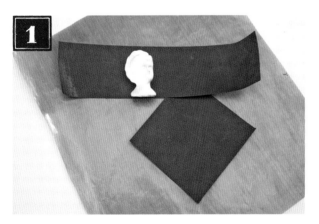

Cut a strip of posterboard ½" (13mm) higher than the height of the object you are making the mold of. This strip must be long enough to form a cylinder around your object, leaving ½" (13mm) around all sides of the object and leaving a few inches (7 or 8 centimeters) of overlap. Cut a base from the posterboard that is 1" (3mm) larger on all sides than the diameter of your cylinder.

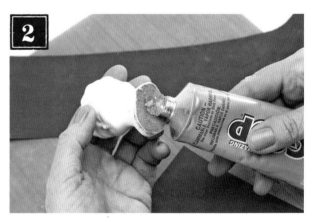

Glue your object to the posterboard base with Goop and let it set.

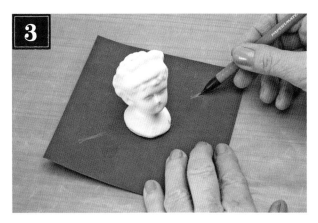

Indicate on the base where the sides of your object are because this is where you will be cutting your mold open, and you want your cut seams to be as inconspicuous as possible.

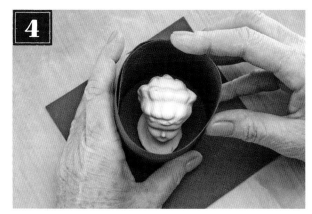

Roll the posterboard strip into a cylinder ½" (13mm) larger on all sides from your object.

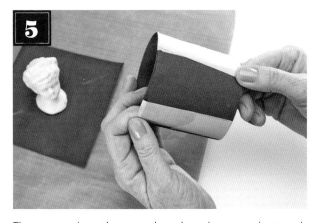

The seams where the posterboard overlaps must be taped inside and out.

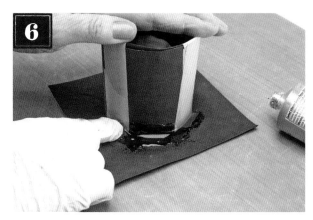

Glue the cylinder to the base with a good amount of Goop and let this dry for at least 1 hour.

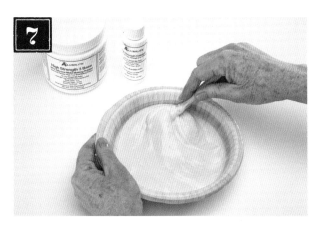

After the glue is set, mix the silicone molding material at a ratio of 10 parts base to 1 part catalyst until it is a consistent light pink.

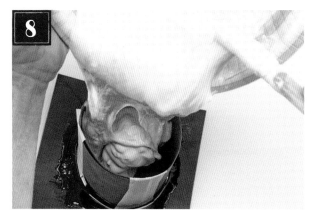

Pour it into your mold container until the material fills it. Wait 24 hours until the mold material sets up.

9

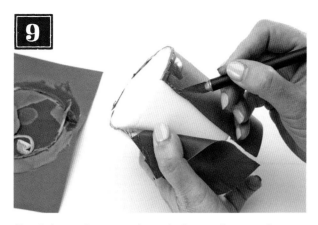

Check the marks you made on the base indicating where the sides of your molded object are, and mark the top of your mold to know where to begin cutting. Use a craft knife to remove the posterboard and tape.

10

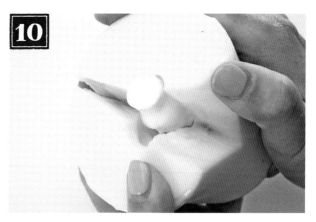

Cut the silicone where you marked on both sides of your mold through to the object inside the mold. Cut to about ½" (13mm) from the bottom, then open your mold and remove the object.

To use your mold, tape it closed and pour in the casting material of your choice. Let the casting material set, then remove the tape and your cast piece.

CASTING MATERIAL OPTIONS

Although we think the resin works best, you can cast with both plaster and powdered clay. They both tend to get bubbles despite pounding the mold on the table to release any trapped air, but sometimes imperfection is a good thing.

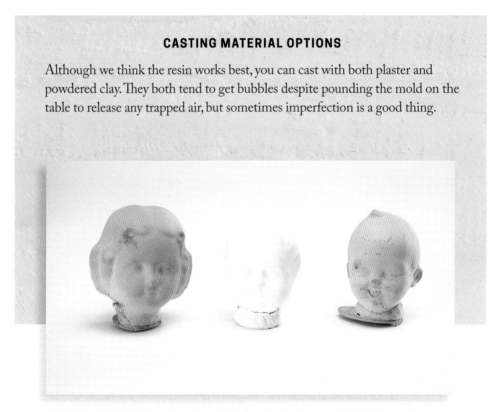

Left to right: ClayShay (powdered clay) cast, plaster cast, ClayShay cast.

JOINING 3-D CAST PIECES

By adhering together several different 3-D cast pieces, you can come up with some wonderful hybrids. With this winged wonder, I used resin casts of a frozen Charlotte head, a body and wings. Glue the resin cast objects with a 5-minute epoxy gel and smooth out odd joints with a resin clay. Next time you find a plastic bird with outstretched wings, you can cut off those wings (sorry, birdy) and make a 3-D mold so that you can cast countless wings.

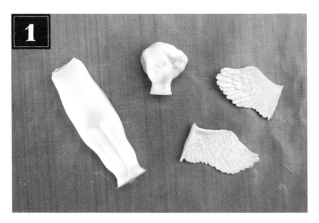

Cast your objects as shown.

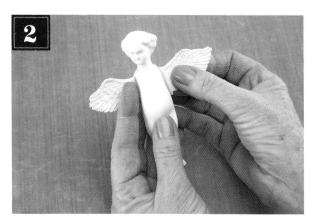

Adhere the pieces together with 5-minute epoxy gel.

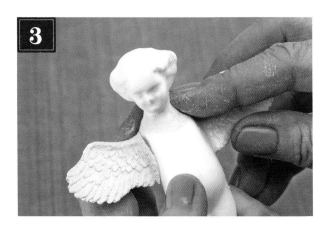

Smooth the joints with resin clay.

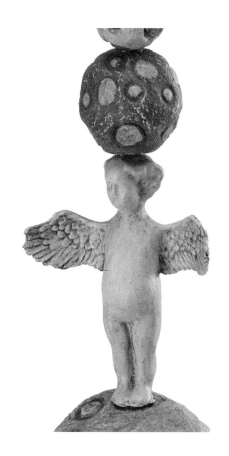

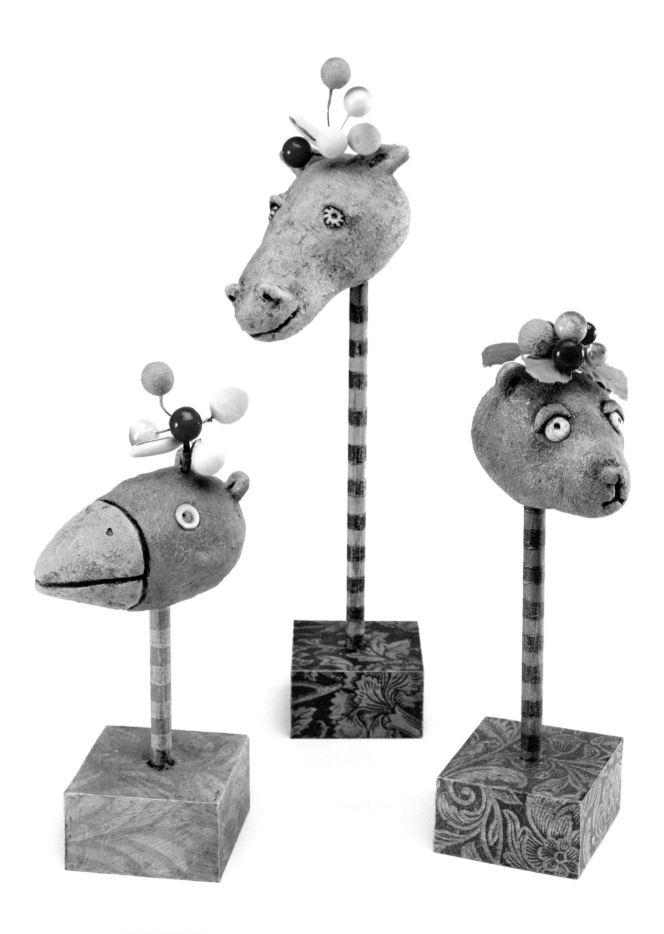

FRUIT HEADS ■ PATRICIA CHAPMAN
Paper mache over carved Styrofoam, painted, wood dowel, embellishments and paper-covered wood base.

STYROFOAM (5)

Perhaps you think of Styrofoam as being lightweight and flimsy. This is true but it has the advantage of being not only very inexpensive, but easy to cut and carve, and when covered with paper mache, powdered clay, plaster or resin clay, this "flimsy" material can be transformed into a durable, permanent art piece. The plain old white, rough Styrofoam, which you can buy in several different shapes, sheets or blocks, makes the most effective base for adhering your clays to. If you want to make larger scale sculptures using a Styrofoam armature, you can glue together several sheets or blocks with either Styrofoam glue or white glue and cut and carve those blocks into any shape or form you can think of.

MATERIALS USED IN THIS CHAPTER:

dowel

drill

embellishments as desired

hot glue or E6000 glue

paints and brushes

paper, pen and scissors

papier mache, powdered clay (ClayShay), paperclay or resin clay

photograph, letter tiles, coins, wires

printed paper

rasp file

serrated knife

stamp

Styrofoam (regular white)

white glue

wood base

CLAY OVER A STYROFOAM BASE

The Styrofoam base provides the bulk and minimizes the amount of clay needed to complete your sculpture. Many clay products work well for this.

Start with a block of foam at least 2 inches (5cm) thick. Draw a basic head shape on paper and then cut it out and trace the shape on the foam.

With a serrated knife, cut out the rough head shape.

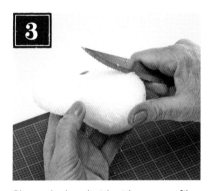

Shape the head with either a rasp file or a serrated knife.

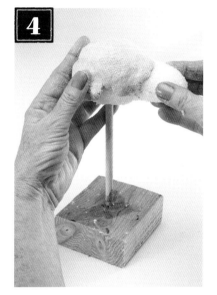

Drill the center of a squared-off wood block (the base) and insert a dowel, then place your shaped foam onto the other end. Apply a layer of paper mache to the head, adding eyes, ears, nose, mouth and any other features you want.

Paint or cover the wood base with printed paper and paint the dowel.

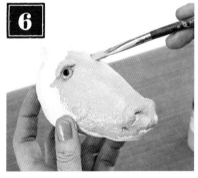

After the paper mache has dried thoroughly, paint the head and add embellishments as desired.

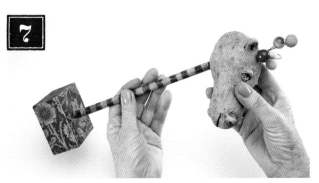

Once all pieces are finished and dried, apply glue to the holes in the block and head, and insert the dowel.

CLAY ON 3-D STYROFOAM SHAPES

Want a figure with some bulk? Building the figure in Styrofoam, which is very inexpensive, saves the cost of extra clay.

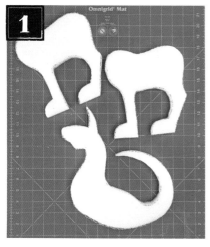

Trace the designs of the different parts on the foam and cut them out.

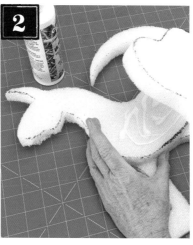

Glue the pieces together with white glue and let it dry fully.

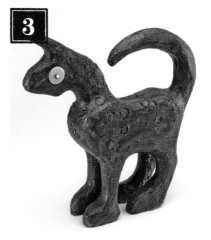

This piece was finished with powdered clay (ClayShay) that was stamped. Then it was painted and embellishments added.

PAPER CLAY ON STYROFOAM

The beauty of Styrofoam is that you can stick wire or skewers into it to add adornments. Applying a layer of paper clay over the foam makes it easy to embellish the surface with texture and stamping.

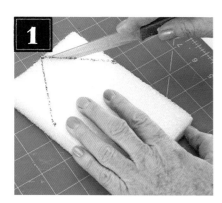

Draw your design in Styrofoam and cut it out.

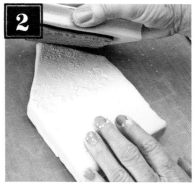

Cover the front and sides of the Styrofoam with paperclay, stamp and let it dry. Repeat on the other and let it dry.

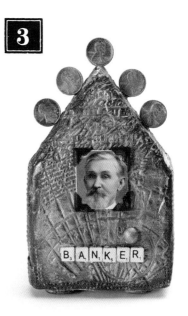

Paint, glaze (to give the texture depth) and add a gold rub (to pick up the highlights). Add the image and letter tiles, and glue coins to wires using resin clay. Insert the wired coins into the foam, adding a little hot glue or E6000 glue for stability.

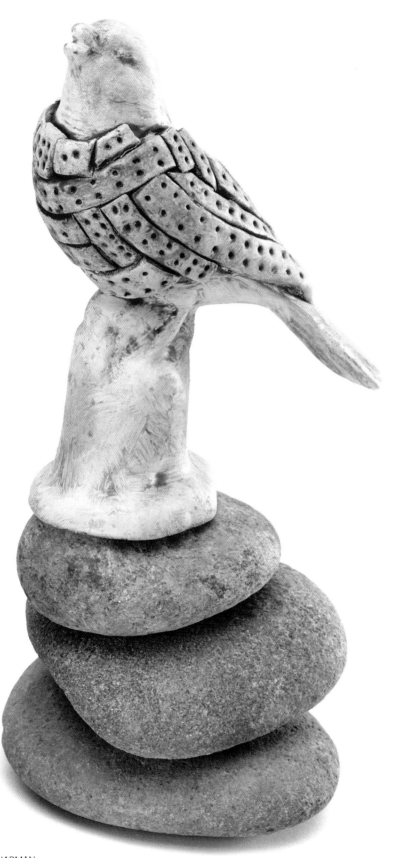

ARMORED BIRD ▪ PATRICIA CHAPMAN
Rocks adhered with resin clay, and bird figurine
with resin clay "armor" and dark acrylic glaze.

ROCK ARMATURES ⑥

Explore your garden or hiking trails to find stones that can make great rock art. You could always return your creative rocks back to the environment to surprise another adventurer or give them as a gift or use them as garden ornaments. These are so much fun to make, can live outdoors or in, and require a minimum of art supplies.

..
MATERIALS USED IN THIS CHAPTER:

acrylic paint stain

brushes

disposable gloves

paper towels

resin clay (Apoxie Sculpt used)

rocks

stamps

CLAY COVERS ROCK

A nice smooth rock makes a perfect base for creating a "message" rock using resin clay. Or you could put some resin clay into a face mold and pull it out of the mold before it sets, then set the molded face onto a rock and gently press and smooth the edges of the face onto the rock.

The two-part Apoxie Sculpt was used here, with parts A and B mixed 50/50. Because Apoxie Sculpt is weatherproof, your finished rock can live indoors or outside.

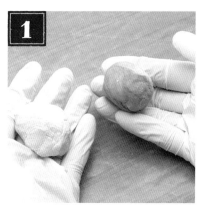

Following the manufacturer's instructions, prepare the resin clay.

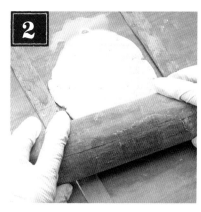

Roll out a ⅛" (3mm) thick slab of the clay.

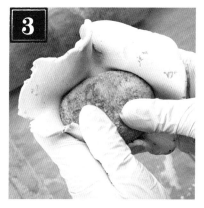

Form and smooth the clay over your rock.

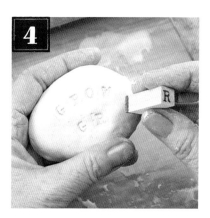

Stamp words into the clay and set it aside to cure.

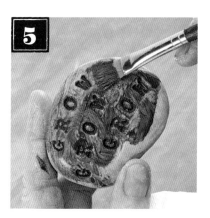

When the clay is cured, brush on an acrylic paint stain.

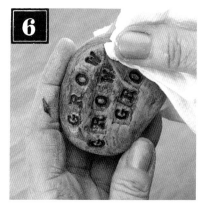

Wipe any excess stain off the clay.

CLAY AS ADHESIVE FOR A CAIRN

These stacked stones have been used as landmarks since ancient times. Add your own creative twist by topping them off with the unexpected or something personal.

Prepare the resin clay you will use to attach the rocks to each other (Apoxie Sculpt, with parts A and B mixed 50/50). This clay is great for indoor and outdoor use.

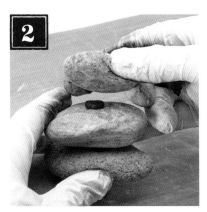

Use small bits of the resin clay to glue the rocks together, working from largest (on the bottom) to smallest (on top).

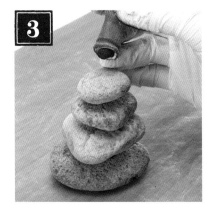

Paint or stain if desired. Attach a topper of choice with the resin clay.

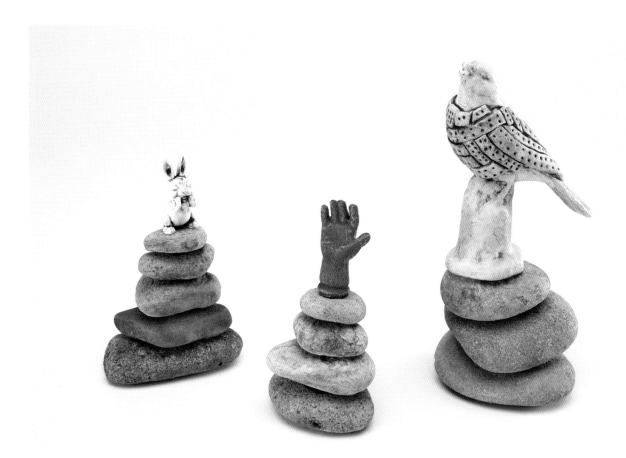

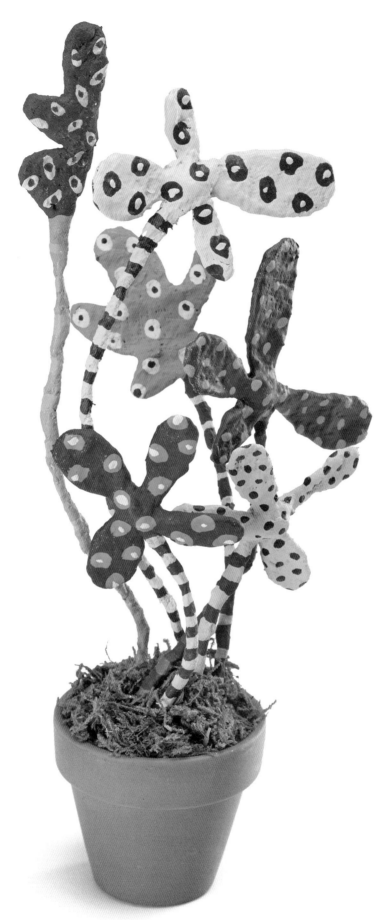

BODACIOUS BLOOMS ▪ PATRICIA CHAPMAN
Twisted wire covered with plaster gauze, painted, adhered to flowerpot with moss added.

WIRE & WIRE MESH (7)

Isn't being strong yet flexible something we all aspire to? Used as an armature, wire can be manipulated into any shape, affixed to a base and then fleshed out with a variety of different clay alternatives. Wire screen that can be covered with clay is another way to create all kinds of shapes, from abstract to realistic.

MATERIALS USED IN THIS CHAPTER:

acrylic paints and brushes

Apoxie Sculpt

bedspring

crocheted doily

dark annealed steel wire

doll

doll embellishments

eyes (doll or taxidermy)

florist's foam

hot glue

metal file or sandpaper

metal mesh

moss (optional)

plaster

plaster gauze

posterboard

scissors

serrated knife

small flowerpot

taxidermy form

white glue

COVERING SHAPED WIRE

The most inexpensive and readily available wire to use for armatures is dark annealed steel wire available in hardware stores. This wire is easy to bend, wrap or coil while retaining enough rigidity to provide a structure.

In this example the wire shapes are covered with plaster gauze and then painted after drying, but these wire shapes could also be covered with many of the other clay alternatives described in this book.

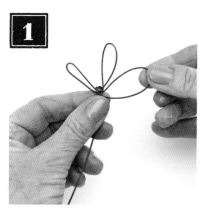

Twist wire into shapes to make your form (in this case, flower petals).

Wrap the forms with small strips of wet plaster gauze.

MATERIALS TIP

The finer the wire, the larger the gauge will be. For the project shown, 19-gauge wire was used.

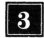

Let the wrapped forms (petals attached to a stem) dry.

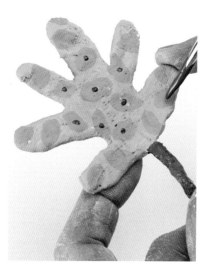

Paint the flower forms using acrylic paint.

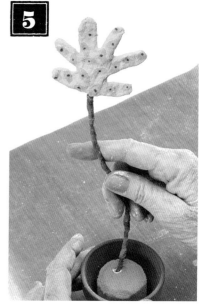

Cut a piece of florist's foam to fit a small flowerpot, using a serrated knife. Glue the foam into the pot with premium crafter's white glue. Stick the flower stems into the floral foam, then pull them out of the foam. Apply glue to the ends of the stems and put them back in the holes in the foam. Add moss if desired and glue into place.

Sign up for our FREE e-newsletter at CreateMixedMedia.com.

BUILDING UPON FOUND WIRE

You can not only fashion armatures with wire, but you can also be on the hunt for objects made from wire that would make great ready-made armatures.

Look for wire baskets, wire racks or shelving, hangers, lampshade frames or old bedsprings. Any of these items can provide a structure for plaster cloth, Critter Clay, paper mache or resin clay.

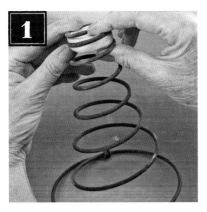

Insert Apoxie Sculpt into the top of an old bedspring to form a small platform.

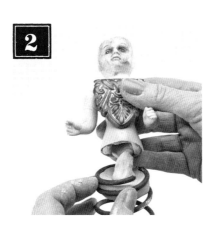

Attach a doll figure to the bedspring using Apoxie Sculpt as an adhesive.

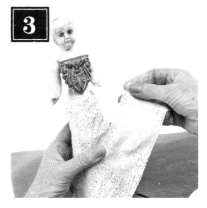

Wrap plaster gauze over the bedspring to form a skirt and let it dry.

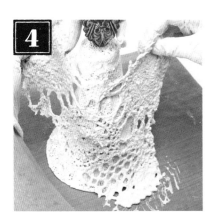

Dip a doily in plaster and adhere it to the skirt.

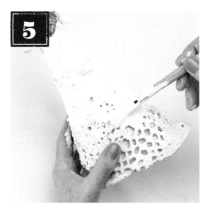

Add paint and embellish as desired.

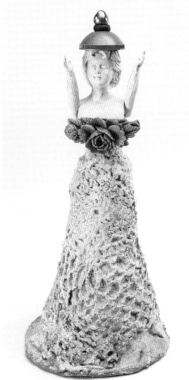

ADHESION TIP

If your figure has very smooth or slick edges or surfaces, scuff them up; the Apoxie adhesive will adhere better. I used a Dremel tool to rough up the parts of the doll that would connect with the Apoxie. You could also use a metal file or sandpaper.

SCULPTING OVER WIRE MESH

Wire mesh has the advantage of being able to serve as an extremely versatile armature, but it can also be used as a sculptural medium on its own. Metal mesh is pliable enough to mold into virtually any shape, but strong enough to provide a structural base for clay, plaster and paper mache. Mold it over an existing form or make your own free-form three-dimensional shapes. It can be crimped, twisted, compressed, expanded or gathered. Finer mesh is excellent for sculpting fine details, and heavier mesh makes a great support for clays or casting compounds.

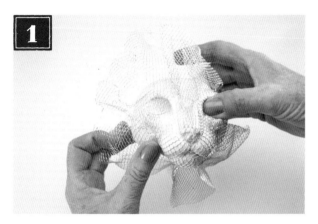

Wrap metal mesh around a taxidermy form.

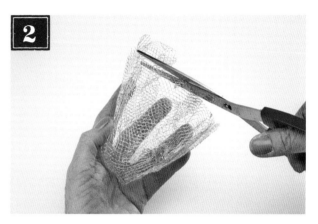

Remove the mesh from the form and trim off the excess mesh from the back of the shape.

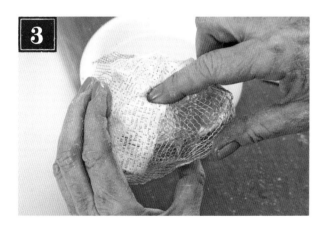

Apply plaster gauze over the wire to conform to the shape and over the back of the piece to create a flat back. Let it dry.

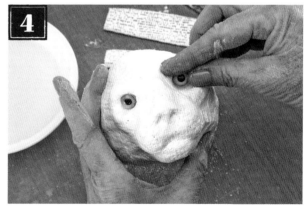

Add doll or taxidermy eyes.

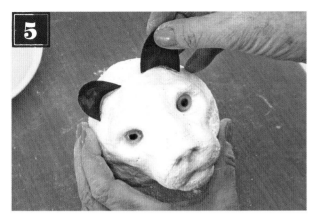

Cut ear shapes from posterboard and add them to the form using hot glue.

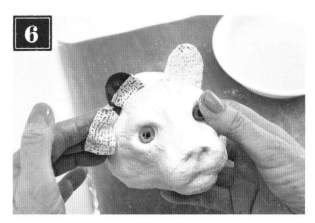

Apply plaster gauze over the ears.

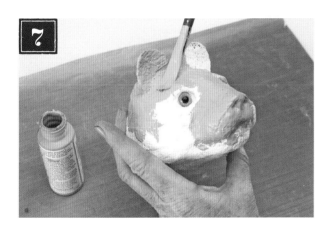

After the head is dry, add paint and place the head in your assemblage as desired using an appropriate adhesive.

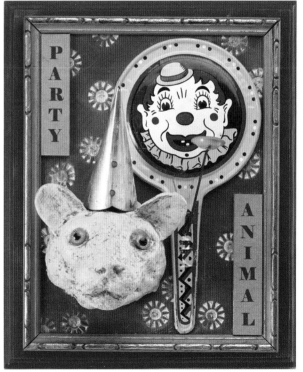

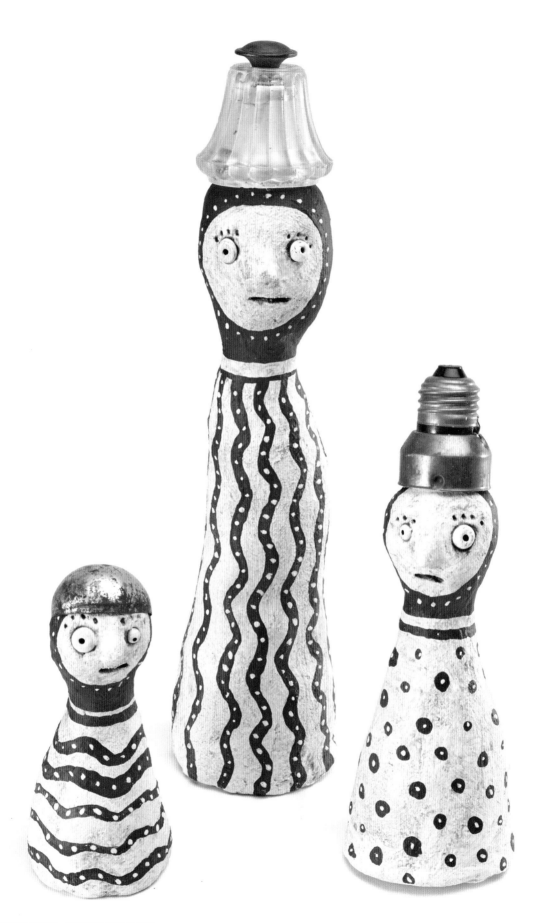

GONZO GUYS ▪ PATRICIA CHAPMAN
Paper mache over aluminum foil, painted, with found objects added.

ALUMINUM FOIL (8)

We love finding art supplies in the kitchen (and getting out of there before somebody expects us to cook anything). One of the best armature materials is plain old aluminum foil. So get out a roll and start wadding it into shapes and covering it with your favorite air-dry clay alternative. Paper mache, ClayShay, Critter Clay, paperclay and resin clay all work beautifully spread over aluminum foil. Foil has the advantage of being inexpensive, readily available, lightweight and very easy to manipulate into any shape or form you can dream up.

MATERIALS USED IN THIS CHAPTER:

acrylic paint and brushes

aluminum foil

beads and/or found objects

epoxy glue (optional)

paper mache, Critter Clay or paperclay

resin clay

strong adhesive

SCULPTING OVER FOIL

The folk-art inspired, whimsical family shown on page 48 is a great example of how deliciously fun and easy working with foil armatures can be. You can always add more foil as you work on your basic shape. If you have trouble attaching additional foil, give it a little help with some hot glue.

shown on page 48

CLAY TIP

If you are using paper mache or ClayShay over the foil, mix it into a very thick, claylike consistency.

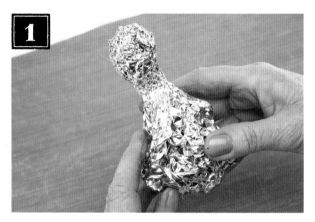

Roll out several inches (17–21cm) of foil and start to crumple it up, shaping and compressing it into the rough shape that you want. Compress until you have a relatively smooth form with no huge dips or spikes.

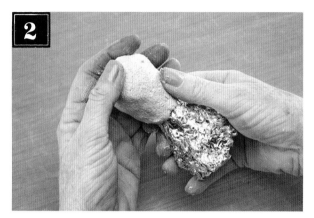

Smooth clay (paper mache shown) onto your foil to form a little at a time, smoothing it together with wet fingers if needed.

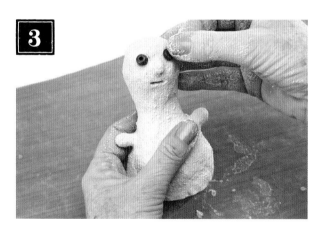

After the paper mache dries, add eyes and any marks or features. For larger, heavier embellishments, attach with resin clay or epoxy glue.

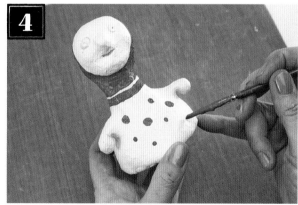

Allow your piece to dry thoroughly before painting. Paint a basecoat of acrylic paint and let it dry. Then add details and an acrylic wash if desired.

ADDING ON WITH CLAY OVER FOIL

An easy way to add an element (like wings) onto an existing structure is to make it yourself. Just shape the foil into a form that's the right shape and size, then cover it completely with resin clay, apply paint and add it to your assemblage.

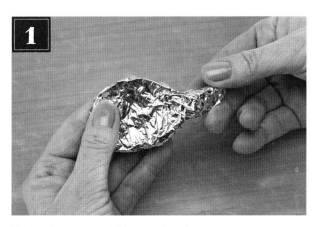

Fold and compress foil into a wing shape.

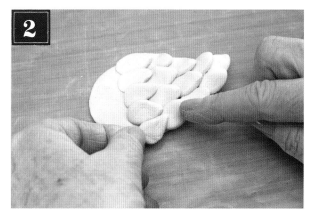

Completely cover the foil wing with resin clay (shown is Apoxie Sculpt). Then apply resin clay petals to create a feathered wing look.

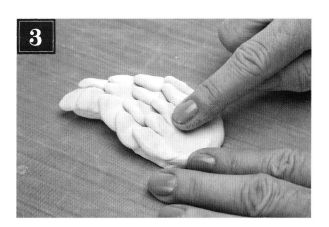

Smooth out the clay as necessary to look like a wing, then let the wing dry.

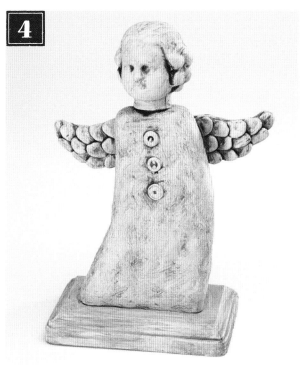

When the clay is dry, paint it and add a glaze, then attach the wing to your figurine using a strong adhesive.

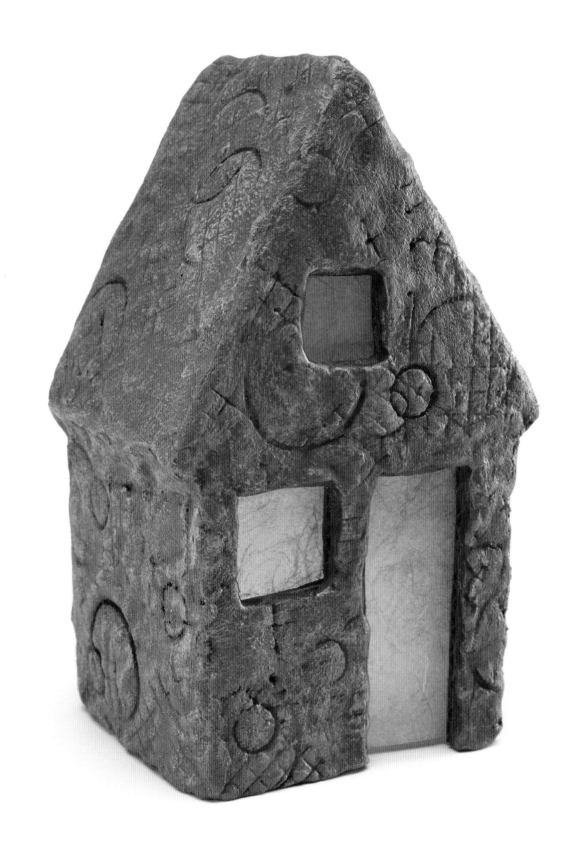

LIGHT HOUSE ▪ PATRICIA CHAPMAN
ClayShay over cardboard, stamped with texture, painted, with tinted rice paper added.

CARDBOARD (9)

If you do much online shopping, you likely have a steady stream of cardboard boxes making their way into your recycle bin. You can recycle that cardboard in a much more amusing way by using it as armatures for your clay constructions. Cardboard cuts relatively easily with a sharp utility or craft knife and can be assembled quickly with hot glue. Just add the clay alternative you prefer.

MATERIALS USED IN THIS CHAPTER:

acrylic glaze

acrylic paint and brushes (including metallic gold)

battery-powered tea light

beads/embellishments

cardboard

craft or utility knife

glaze or stain (optional)

hot glue gun

paper

paper towels or rags

paper mache

posterboard

stamp (optional)

translucent rice paper

white glue

CONSTRUCTING A HOUSE

Shown is the basic template for the pieces needed to build yourself a cardboard house using paper mache to cover it. Feel free to make it whatever size suits you, to change proportions, and to add more windows or perhaps a chimney.

1

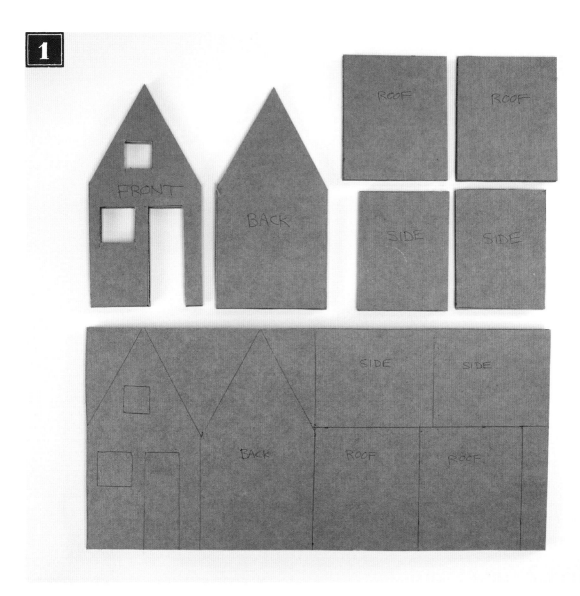

Trace your own pattern pieces onto cardboard and cut out the pieces.

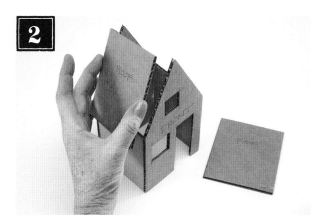

Glue together the cut pieces using hot glue.

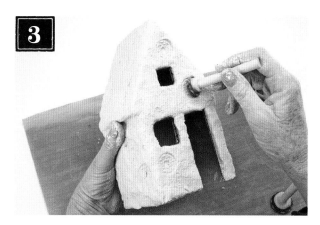

Cover the house with paper mache, stamping on some texture if desired. Let dry.

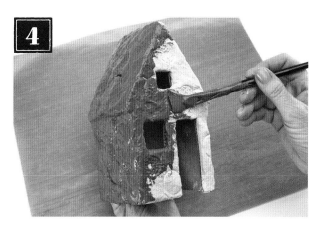

Once the house is dry, add paint and let dry.

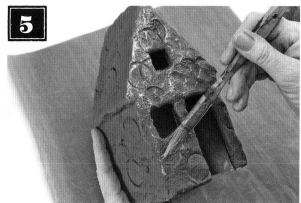

Drybrush metallic gold paint over the base paint.

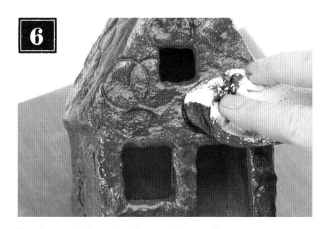

Brush on a dark acrylic glaze and wipe off to accent recessed areas.

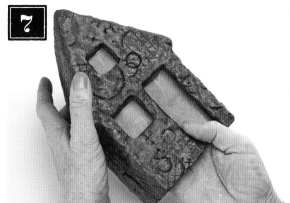

To cover the door and windows, adhere the translucent rice paper (colored with a wash if desired) inside the house with a crafter's premium white glue. To warm the house, add a battery-powered flickering tea light inside for an inviting glow.

STACKING FOR A DIMENSIONAL FIGURE

You can create dimensional bulk with cardboard by cutting out shapes and gluing together stacks of your cardboard cutouts. Then cover the armature with Apoxie Sculpt, ClayShay, paperclay or paper mache clay and add texture, embellishments and/or paint.

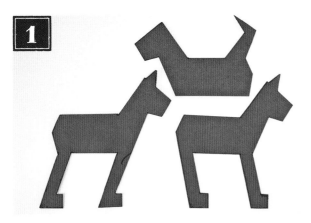

Start with an outline drawing of the piece you have in mind (here, a Cubist cat) and cut three of each of the template pieces out of cardboard.

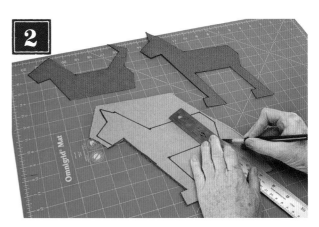

Trace and cut the template pieces out of cardboard.

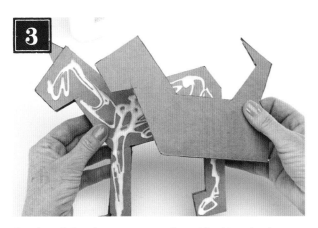

Stack and glue the pieces together with white glue, hot glue or rubber cement.

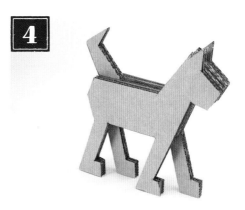

Let your fully dimensional, free-standing cardboard cat dry.

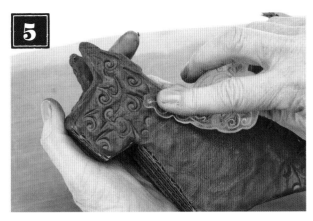

5

Cover the cardboard with the clay of your choice (red resin clay is used here), and stamp a texture into the surface before it starts to harden.

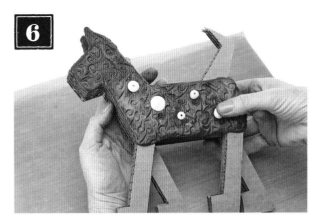

6

Add embellishments while clay is still pliable.

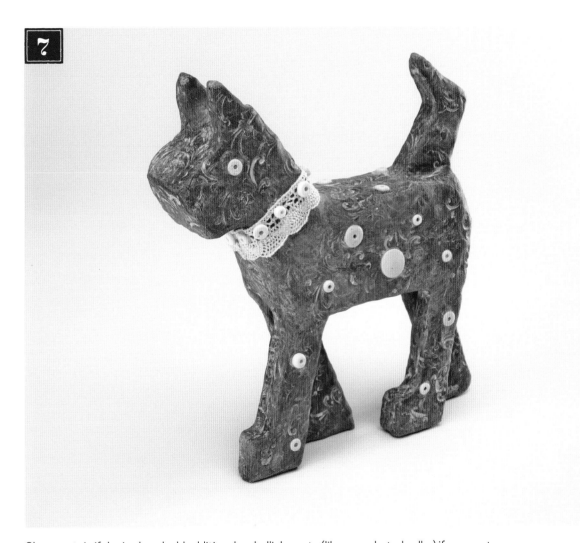

7

Glaze or stain if desired, and add additional embellishments (like a crocheted collar) if you want.

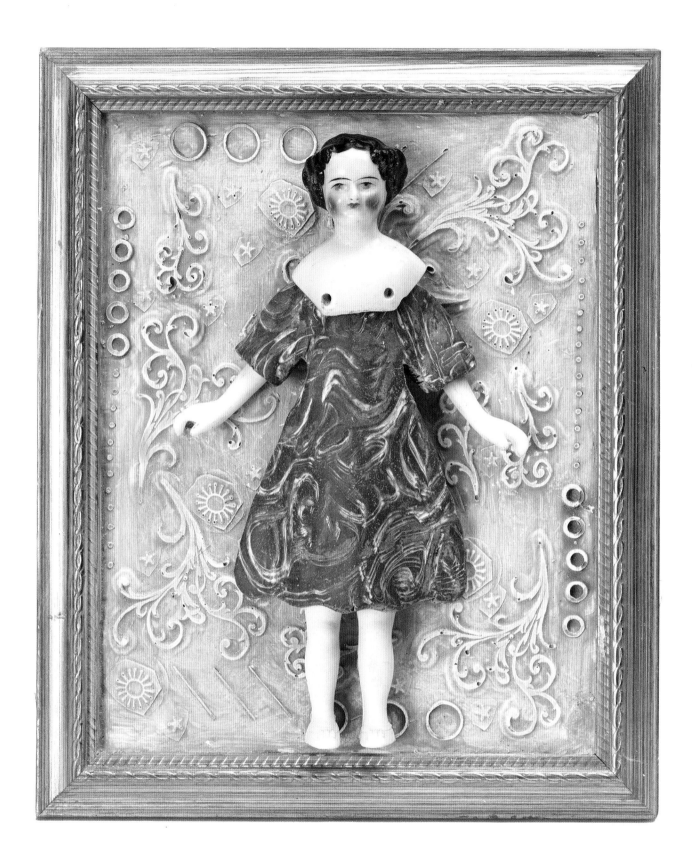

BEST DRESSED ▪ PATRICIA CHAPMAN
Plaster cast in frame (see Chapter 16, Frame Casting), acrylic glaze brushed
on plaster and wiped off, resin clay stamped with gel plate pattern, light
acrylic glaze on resin dress, doll parts, wood dowel and epoxy glue.

GEL & ⑩ MODELING PASTE

Gel and modeling paste can do so many things—extending paint, acting as a glue, texturizing a surface—but who knew these products would be great to make a mold for casting? You can cast with plaster, resin clay and even powdered clay in your gel or modeling paste. Before you try casting with them, be sure to read all the information on these casting mediums in this book so you understand their qualities and use. Once you get a good handle on this technique, try some of the other pastes like crackle paste and coarse molding paste.

MATERIALS USED IN THIS CHAPTER:

300-lb. (640gsm) watercolor paper

acrylic paint and brushes

aluminum foil

brayer

craft or utility knife

GAC 800 sealant

gel or modeling paste

marking tools

palette knife or spreader

plaster of Paris

polymer gel

resin clay (Apoxie Sculpt used)

texture plate

optional: dowel or rolling pin

MOLDING VS. MODELING

Molding paste and modeling paste are virtually the same product. Different companies do not always name their products the same.

GEL AND MODELING PASTE CASTING WITH PLASTER OF PARIS

You can use either gel or modeling paste to make your mold to cast with. You need a heavy but flexible surface to use as the base for your mold; we prefer 300-lb. (640gsm) watercolor paper (a lighter paper may warp a bit). With this technique, the heavier the gel or paste, the better shapes will hold because of the stiffer binder. Layer raised gel or paste stencils on top of a dry texture, or scrape away gel or paste while it is still wet to add to or subtract from it. Variations are endless with this technique.

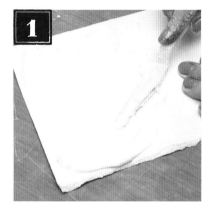

Spread hard gel gloss on a piece of heavy watercolor paper.

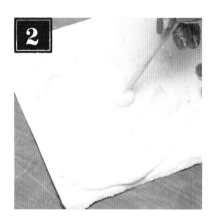

Make lines, shapes or marks in the gel and let it dry.

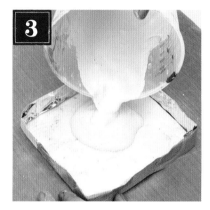

Add an edge with aluminum foil, making a box shape around the gelled paper, then pour in the plaster.

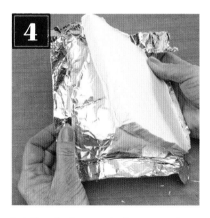

Let the plaster cure before removing the mold. It will set up in approximately a half hour.

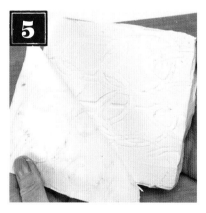

Carefully pull the paper off the plaster once it has dried.

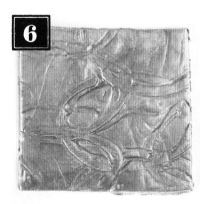

Wait until the plaster has cured for several days (until it is bone dry) before painting it with acrylics. Seal with GAC 800.

GEL AND MODELING PASTE CASTING WITH RESIN CLAY

When working with resin clay, coat your gel or modeling paste plate with cooking spray or mold release to keep the clay from sticking. Also let the clay cure on butcher paper (the shiny side) or plastic as it may stick permanently to other surfaces.

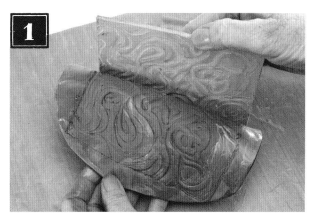

1

Lay a ¼" (6mm) layer of prepared resin clay on your gel or modeling paste plate and brayer to transfer the pattern. Red Apoxie Sculpt is used here. (Apoxie Sculpt comes in twelve different colors and can be custom colored if desired.) Remove the clay from the plate.

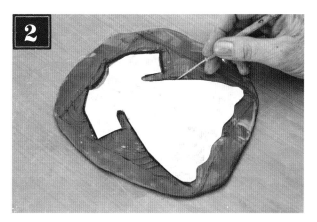

2

Trim the edges or cut the patterned clay into shapes (like the dress shown at the beginning of the chapter). Let the clay set up for about two hours until it begins to stiffen but is still pliable.

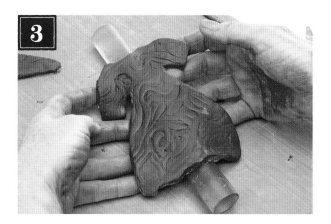

3

Lay the clay over a dowel or rolling pin to shape it if needed (in this case, to drape the dress). Then let the clay set up fully and add it to your assemblage. Paint the clay and add a contrasting color glaze if desired.

Detail of patterned clay.

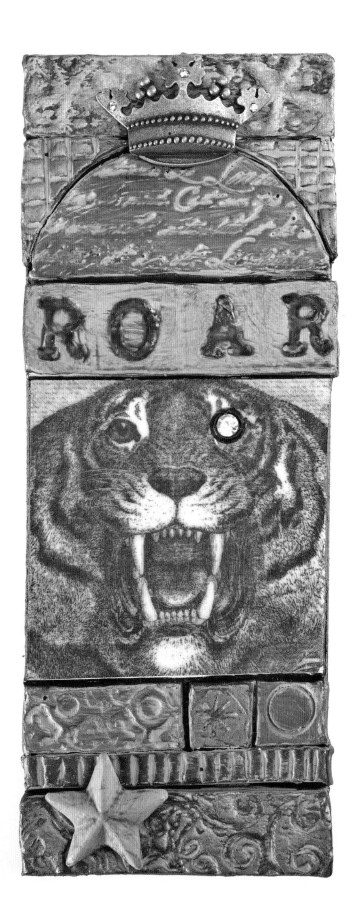

ROAR ▪ PATRICIA CHAPMAN
Slabs of Critter Clay stamped with texture and painted, printed image and embellishments added.

CRITTER CLAY (11)

The winner of the "Best Imitation of Traditional Clay" award is … drum roll please … Critter Clay! Critter Clay looks, feels and works like traditional clay. Like traditional clay, with Critter Clay you can do slab work, molding, coiling and even wheel throwing. One of the biggest differences though is that this clay isn't going anywhere near a kiln. This premium air-dry clay has a 0–1 percent shrinkage rate, is extra-durable, ready to use, cleans up easily with water and will accept any paint. Depending on the thickness of your project, the dry/cure time will be 1–6 days. After it dries, it can be sanded, drilled or carved, and it comes in a basic clay gray and a white color. Wonderfully versatile slabs can be used to create big or small sculptures, vessels, bowls or boxes. So get rolling!

CRITTER CLAY TIPS

- The best surface to roll your slabs on is raw canvas laid out on your worktable.

- Use wood strips of equal thicknesses on each side of your clay as you roll it to ensure that you are rolling out a slab of even thickness.

- If you pick up the slab and turn it over and crosswise as you roll, it will dry flat without warping.

- When attaching slab pieces together, it helps to wet and score the backs or edges of the pieces you are working with.

- Thinner modeled elements will be very fragile. Added thickness makes your creations much more durable.

MATERIALS USED IN THIS CHAPTER:

acrylic paint

brushes

canvas (optional)

craft knife

Critter Clay

cup of water

embellishments (like rusty nails)

foamcore

glue

mark-making tools

old book pages

paper patterns of birds

paper towels or rags

pattern for mosaic

posterboard or cardstock

rolling pin

skewer or needle tool

soft gel medium

stamps

wood strips (to roll an even slab)

WORKING WITH SLABS

Roll out a slab of clay and prepare yourself for unlimited possibilities. You can create big or small sculptures or vessels with your slabs. Emboss, inscribe, texturize, carve, stamp, cut and assemble your slabs in any way you can dream up. Create mosaic pieces or components for your mixed-media art.

1

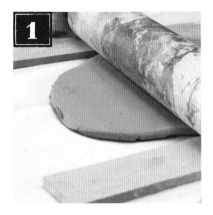

Roll out a slab with wood strips to get a consistent thickness.

2

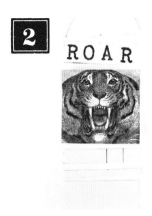

Make a pattern for your mosaic showing text and images.

3

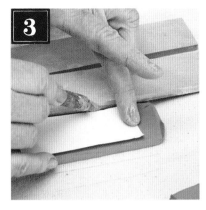

Use the pattern as a template to cut individual sections of clay.

4

Stamp texture and alphabet letters into the clay and let all the pieces dry.

5

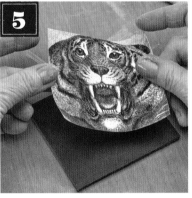
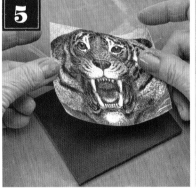

Cut a piece of foamcore to the size of your image, and adhere the image to the foamcore using soft gel medium. Then brush the medium over the adhered image.

6

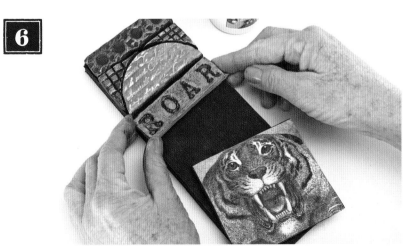

When all the clay pieces are dry, paint them and then adhere all the pieces to a piece of foamcore, plywood or MDF using E6000, premium white glue or epoxy glue.

MAKING STAMPS

You can make texture stamps by taking a hunk of clay, shaping a handle and flattening the other end. You can carve, poke or mark a pattern into the flat end, let it fully dry/cure, and you have an excellent tool for stamping texture into all kinds of clay. If you want your stamp edge to be flatter, just sand it with a flat piece of sandpaper.

Shape the clay into a cone shape.

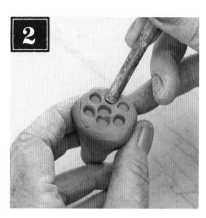

Add a design to the flattened end and allow it to dry.

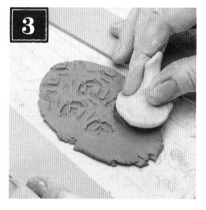

Use these stamps to emboss almost any type of clay/alternative in this book.

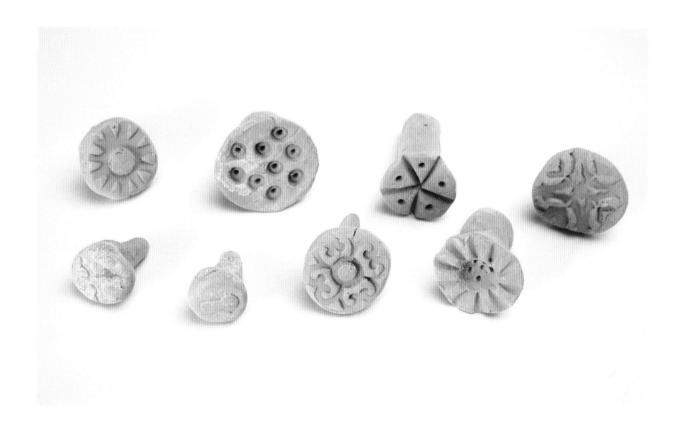

ALL-CLAY FRAMED ART

Explore the possibilities of creating a "frame" using narrow slab strips adhered to the perimeter of a larger slab and inscribed or stamped to create texture. Once your slab piece has fully cured, you will be able to finish the piece with any kind of paint or wash that you want. Cut out shapes to place within your frame that can be covered with paper or any other collage element.

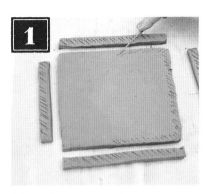

After rolling out your slab, cut out your base and sides and score all edges with a clay tool.

Wet the scored edges of the base and the strips, and attach them together.

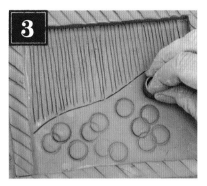

Make marks in the clay to decorate the frame and to create the artwork inside. Set this aside to dry.

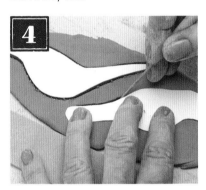

Trace and cut bird shapes out of more clay. Let them dry, flipping the birds frequently to avoid warping (this may take 1–6 days to dry thoroughly).

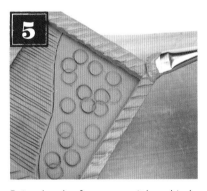

Paint the clay frame once it has dried.

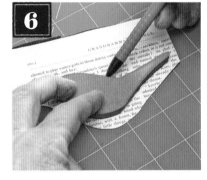

Trace book pages to roughly fit the bird shapes. Adhere the pages to posterboard or cardstock first, because putting lightweight paper directly on the clay may result in visible bumps and wrinkles.

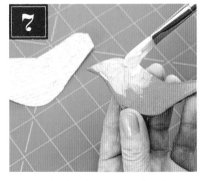

Adhere the book pages to the clay birds using soft gel.

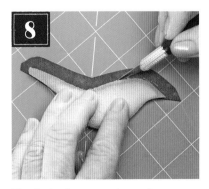

Flip the birds over and trim the excess paper.

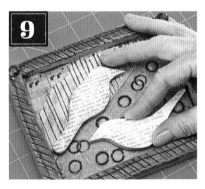

Adhere the birds in the frame using epoxy glue or premium white glue.

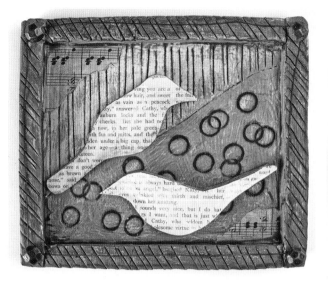

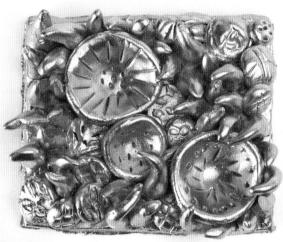

Seeking more dimension? Try this high-relief option following the instructions below.

HIGH-RELIEF CLAY ART

Because of its excellent modeling abilities, with Critter Clay you can create any kind of modeled shapes that can be adhered to a clay background to create a super-high relief texture. This would be a particularly wonderful way to make individual tiles, or you could cover the entire surface of a giant sculptural piece.

When attaching your molded clay components, be sure that you score and wet both the surface you are adhering your shapes to and the underside of the shapes themselves. Go ahead and go for some way-out dimensional elements!

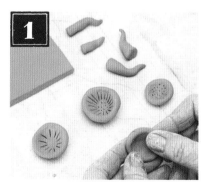

Roll out and cut a clay slab base. Form a variety of shapes with more clay.

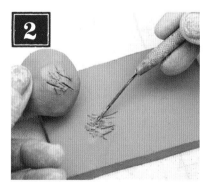

Score the bottoms of the shapes and the base where they will go.

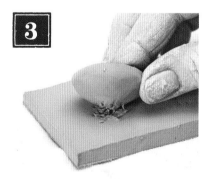

Brush a little water onto the scored parts before pressing the shapes onto the base. Let this dry anywhere from 1–6 days (depending on the thickness of your clay pieces) before painting.

CREATING BEADS

You can easily model any shape or size of beads with Critter Clay. Create texture on your beads with stamps or other clay tools (even a pencil becomes a clay tool when you use it to poke a series of holes for a texturized surface). Run a skewer through your bead from both ends to make sure the hole on each end is smooth. Once your beads are fully cured (1–2 days depending on their size), you can paint them with any paint you choose and apply any acrylic varnish if you want extra shine and durability.

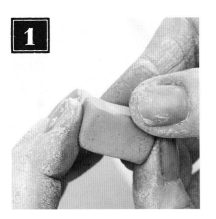

Work the clay to form the shape and size of bead that you want.

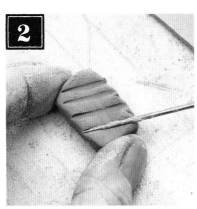

Make marks into all sides of the clay for your design.

Skewer the bead from both ends to make a smooth hole.

Once the bead has fully cured, paint it. When dry, drybrush on a darker acrylic glaze and wipe off excess to accent recessed patterns.

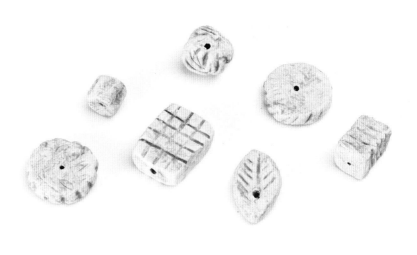

COILED VESSELS

One of the most basic and simple methods of hand constructing in clay is the coiling process. Just roll out thick or thin "snakes" of clay and start building a pot or a coiled figure. You can either smoosh (technical term here!) your coils together to form a smooth surface, or you can leave your coils in all their snaky, well-defined glory to create any kind of coiled design. For smaller coiled projects you won't need an armature or form to build over, but for larger pieces you will need some kind of support.

Make a pinch pot base.

Form a coil and score the bottom of it and also where it will be placed on the base. Brush a little water onto the cored parts and press them together.

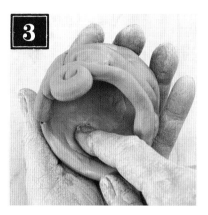

Keep adding coils to the base as desired to form a small pot. Smooth the inside of the pot.

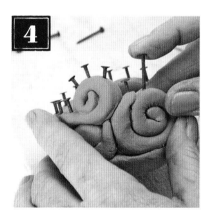

Insert rusty nails or other embellishments on the rim of the pot while the clay is still moist.

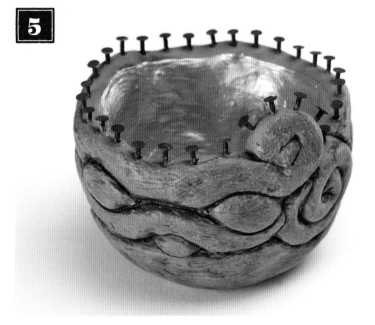

Once the clay has dried, paint the inside and the outside of the pot as desired.

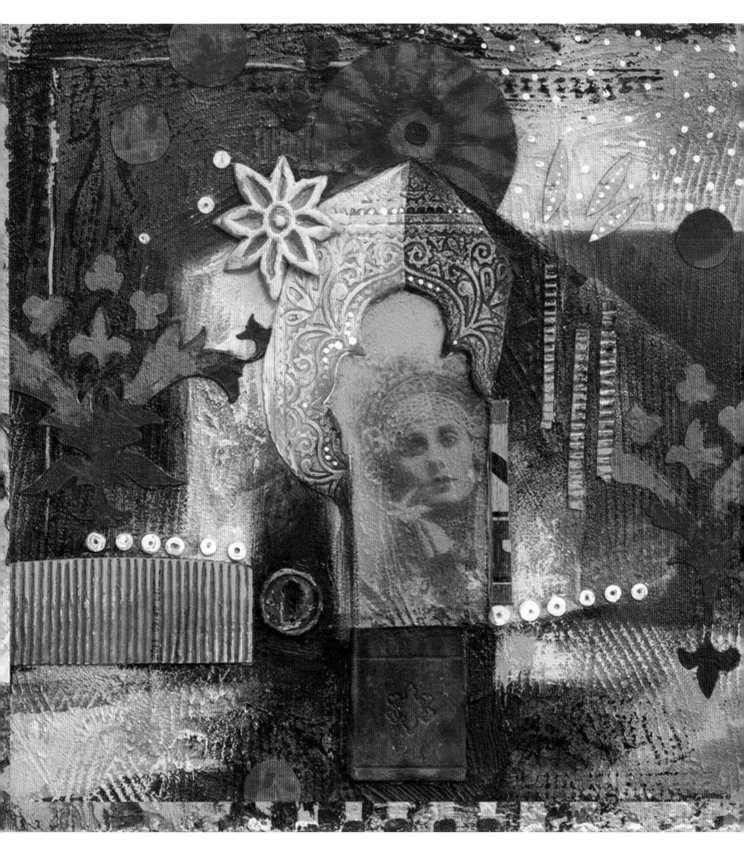

HOUSE OF THE RISING SUN ▪ DARLENE OLIVIA MCELROY
Cast and embossed paperclay, deconstructed fiber paste stencils.

PAPERCLAY (12)

What artist doesn't love texture? With paperclay, it is very easy to add dimension to your art, plus paperclay is so much fun to use. It takes textures and marks from texture plates, stamps and clay tools beautifully. When dry, it becomes a hard yet absorbent surface that is heaven to paint on. Think of the fun you will have trying different painting techniques on the dry clay! A bonus is that paperclay also sticks well to almost any surface if you want to apply it directly to your art surface as an alternative. If you want raised cast collage elements, create them with molds using a two-part molding putty. Add the paperclay to an armature for three-dimensional pieces or make jewelry using it. This versatile product works well with craft projects as well as fine art. The clay takes about 24 hours to dry.

(Please note: In this chapter, when we say "clay" we are referring to paperclay.)

MATERIALS USED IN THIS CHAPTER:

acrylic glaze

acrylic paint

adhesize size

brayer or rolling pin

brushes

craft or utility knife

cup of water

disposable gloves

gesso

mark-making tools

Masonite or plywood

metal leaf

orange

paper

paperclay

stamps

tracing paper

word or letter stamps

PAPERCLAY SLABS

Roll out paperclay and stamp into it with a texture plate, embossed wallpaper or any mark-making tool. Speed up the drying process by flipping it over when one side is dry. Making your textured pieces on a polypropylene cutting board will prevent any warping and will allow the clay to peel off easily. You can trim the clay when it is either damp or dry. When it is completely dry, you can sand it and do almost any surface treatment to it.

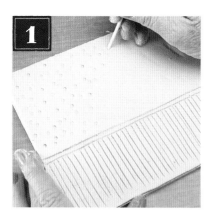

Roll out paperclay and cut into a rectangle. Brush a piece of painted Masonite or plywood with some water and press the clay slab onto it. Trim clay to fit the backing and make marks with whichever tools you choose.

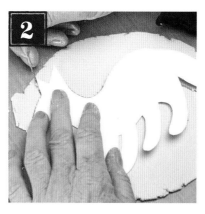

Draw a simple animal shape on paper and cut it out. Trace and cut the shape from a rolled slab of clay.

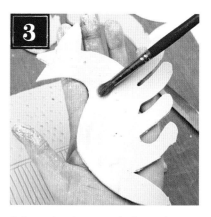

Adhere the shape to the base clay using brushed-on water.

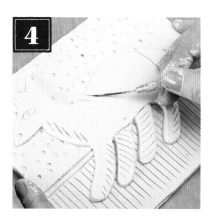

Add more marks to the animal shape, and cut out and add star shapes and words stamped into the clay.

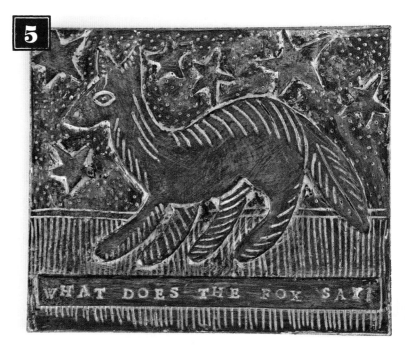

When the clay is completely dry, paint it with a dark color. When the paint is dry, brush on and then wipe off a lighter acrylic glaze.

PAPERCLAY ACCENTS AND RELIEF

Paperclay can be applied directly to artwork for small accents or for larger shapes and textural areas. For larger areas, apply clay directly to the art surface, then trim it into the rough shape you want. After making your marks, you may want to trim again to clean up the edges.

When making a paperclay relief, you can either work in thin layers—letting them dry before adding on more clay for additional elements—or work with a single layer of paperclay. If you find the clay is not sticking well, just lightly wet the surface.

Make a thin roll of clay and apply it to your art for an accent, then stamp or make marks in the clay (it will flatten out a bit as you do this). When dry, the clay is ready to paint.

For a paperclay relief, start by using tracing paper to transfer your drawing onto a wood panel.

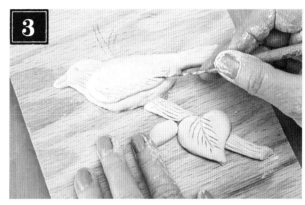

Lay ⅛" – ⅜" (3mm–10mm) thick paperclay over the design, then shape it and mark it using mark-making and clay tools.

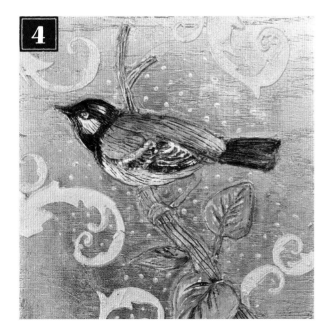

When the relief is dry, gesso the whole panel. Paint the bird. After the bird is painted, apply metal leaf by first applying adhesive size for metal leaf. When the size is tacky, lay the metal leaf on it and rub down lightly.

(Stencils were created on a polypropylene sheet with tinted coarse molding paste. When dry, the pieces were separated and glued down with soft gel.)

ADDING COLOR TO PAPERCLAY

Whether you paint your clay before you work with it or after it has dried is up to you. Tinting your clay beforehand saves you a painting step later, plus if you sand it, you will reveal the tint color rather than the white of an untinted clay. The amount of acrylic paint you add when tinting depends on how dark you want your paperclay to be.

I prefer to apply a layer of matte medium on dry paperclay prior to applying a stain or painting the surface because it makes the clay less absorbent.

Put acrylic paint on top of paperclay and fold over. Be sure to wear disposable gloves to protect your hands from the paint.

Knead well to color the clay.

Tint the clay with acrylic paint before molding.

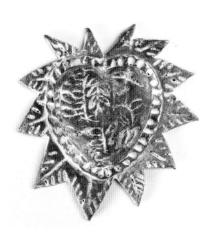

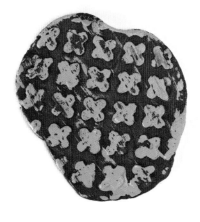

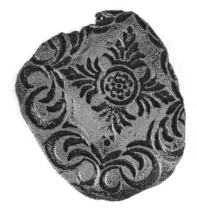

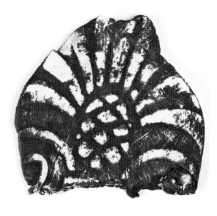

Clockwise from top left: painted with red acrylic paint and topped with white acrylic glaze; Teal drybrushed over a Red Oxide base; Burnt Umber sanded to reveal white clay; gold rub on red-painted, stamped paperclay; silver rub and salt applied over wet black paint for an aged metal look.

MAKING MOSAIC TILES

This technique can be done with many of the clay products in this book as well as paperclay. Roll out your paperclay, then stamp into it with a texture plate, embossed wallpaper or anything that makes a good mark. Trim into shapes with a metal ruler or knife and let dry. When dry, apply paint or metal leaf. Glue the tiles to your art surface with soft gel. GAC 800 gives your tiles a super-glossy, hard finish.

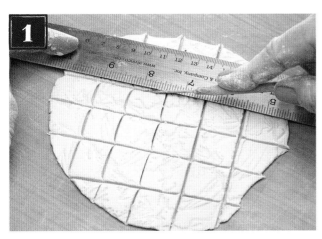

Texture your clay, then trim.

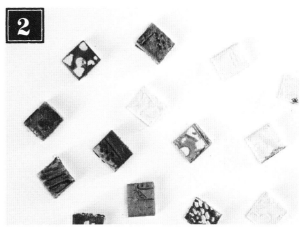

Let dry, then apply paint and finish.

CASTING A BOWL

An easy way to make a bowl is to apply paperclay to the outside of an orange. This will give you a great texture (complete with belly button) on the inside of the bowl. If the orange texture is not your thing, cover the orange with plastic wrap before applying the clay for smoothness and easy removal.

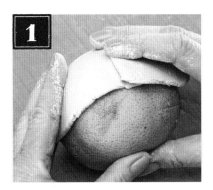

Place clay over an orange, stamp into it and let it dry before gently squeezing the orange out of the bowl.

Add a coil to the bottom and flatten it to form a base.

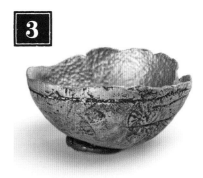

Stain and paint. Note the texture of the orange inside.

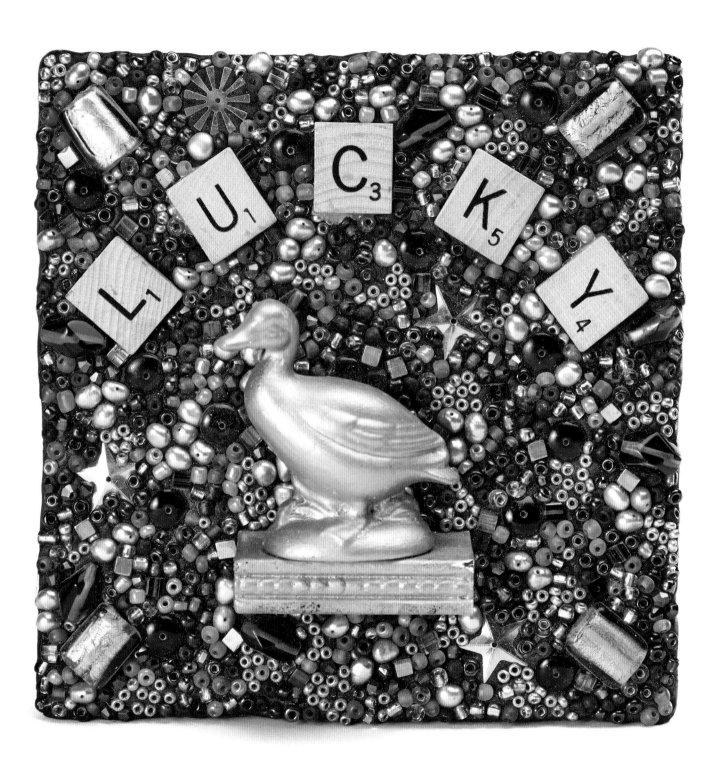

LUCKY DUCK ▪ PATRICIA CHAPMAN
Resin clay and beads over plywood piece, small painted 3-D cast resin duck, shelf and Scrabble tiles added.

RESIN CLAY (13)

Resin clay has been around for years, but once I figured out what this miraculous substance could do, the skies above me opened and golden beams of light poured down. It is incredibly easy to use. It comes in several different colors, but you can create almost any custom color you want by mixing existing colors or by blending it with acrylic paints. Resin clay is perfect for making "groutless" mosaics by embedding any beads, charms or other objects into it. And it is a fabulous sculpting medium that self-hardens with zero-percent shrinkage and is crazy durable when it is fully cured. After it is cured, it can be sanded, drilled or carved. Used as an adhesive, it creates an amazingly strong bond between even the most wildly different materials and surfaces. There are so many fun possibilities.

MATERIALS USED IN THIS CHAPTER:

acrylic glaze

acrylic paint

beads and objects

bezel

brayer

brushes

buttons

disposable gloves

frame or other object

glass doll eyes

masking tape

paper towels

resin clay (Apoxie Sculpt used)

silicone press molds

skewer or needle tool

small taxidermy form

GENERAL TIPS

- When rolling a slab of resin clay, use either a silicone or Teflon mat. Wet the mat, both the top and bottom of your resin clay, and your rolling pin with water to keep the clay from sticking.

- Always allow your resin clay pieces to cure on your nonstick mat because this stuff will adhere itself to anything else.

USING RESIN CLAY AS AN ADHESIVE

Perhaps the most basic use of resin clay is as an adhesive. It is an assemblage artist's dream come true. It is especially useful when you are adhering one uneven surface to another uneven surface. The clay does a fantastic job of filling in those gaps. It will set in 3 to 4 hours, but count on not moving anything you have adhered for the 24 hours that it takes to fully cure.

Apply resin clay to both pieces before pressing together.

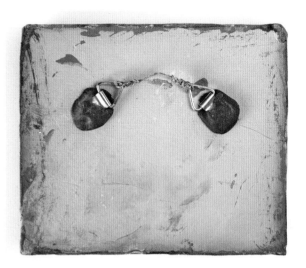

Resin clay is great for adding hangers to slick surfaces.

COLORING RESIN CLAY

This is one messy procedure, so be sure to wear your disposable gloves. Knead the paint into your resin clay until you get a consistent color (there is no specific ratio of paint to clay, but this does work best with white resin clay). Darker shades of acrylic will produce more saturated colors. Resin clay can take paint beautifully and can be painted in either its wet or fully cured state. Powdered pigments (such as Pearl Ex) can also be brushed onto the surface of uncured clay or brushed into a mold before you press the resin clay in, for even more color options.

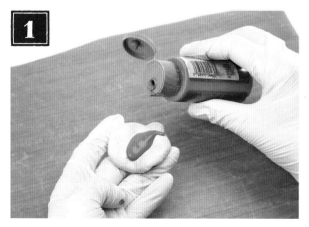

Put acrylic paint on top of the resin clay and fold it over. Be sure to wear disposable gloves to protect your hands from the paint.

Knead well to color the clay.

COVERING FORMS

You can carve Styrofoam into the shape of an animal, buy small paper mache or plastic animal forms, or go to a taxidermy supply store to get a life-size mold of your favorite animal to apply resin clay over. You can cover forms that aren't animals, too.

Cover a small plastic animal form in resin clay.

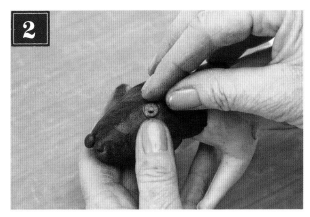

Add glass, plastic or bead eyes while the clay is still pliable.

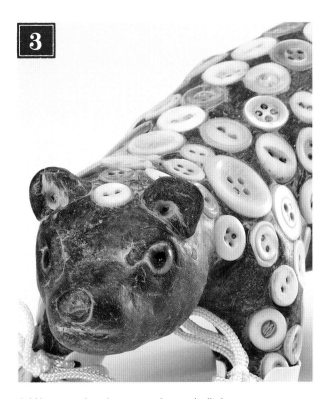

Add buttons, beads or any other embellishments you choose before the resin clay starts to set up (about 3 hours).

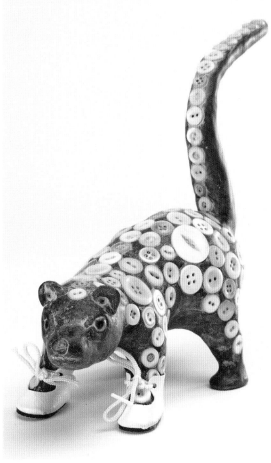

CREATING EMBELLISHMENTS AND ADD-ONS

You can create countless embellishments and add almost anything to any surface or object with your resin clay. Sculpt, stamp or get out your silicone press molds and make a bunch of molded designs to provide all kinds of visual interest and variation to your art.

1

Roll resin clay into a thin "snake."

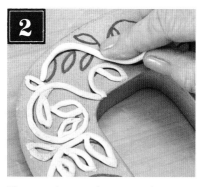

2

Shape and press clay onto a design you have drawn on a frame or other object.

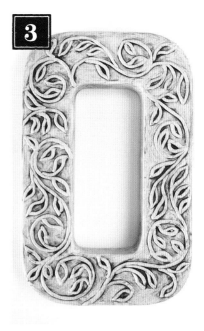

3

Paint or stain as desired.

INCREASING PLIABILITY

If your resin clay is stiff and difficult to work with, put it in a plastic bag and heat it in the microwave for 8 seconds. It will come out pliable.

ROLLING ON INLAYS

Try adding a contrasting color of resin clay as a design inlaid into the surface of a different colored resin clay. Roll out snakes or form little balls and press them into the surface with a roller. You can create words, random designs or allover patterns.

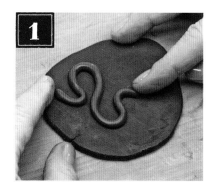

1

On a slab of colored resin clay, apply colored snakes.

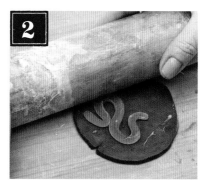

2

Roll into the clay with a brayer.

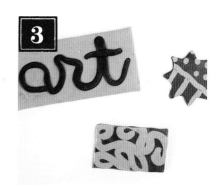

3

You can make inlays with words, dots or funky designs.

BUILDING BEAD MOSAICS

What's more fun than making mosaics? Cover any surface or object with a layer of resin clay at least ⅛" (3mm) thick (thicker if you are using exceptionally large or long beads that protrude). You can either roll out the clay and press it onto your surface or just take pieces of the clay that you flatten by hand and press on. Add beads of all kinds and other elements if you want (letter tiles, typewriter keys, alphabet pasta—you name it!).

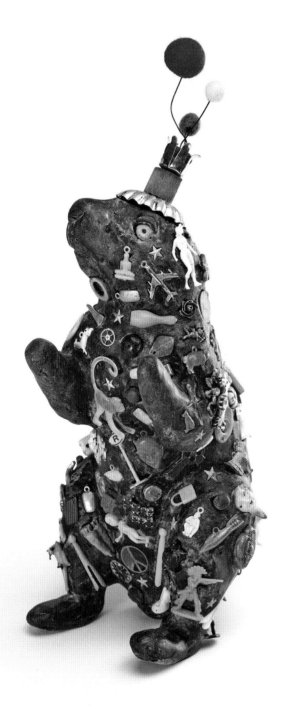

Cover any object (animal forms, dolls, picture frames, your car!) with resin clay and create dimensional mosaics by embedding small objects, beads, glass or ceramic tiles, or anything else you can think of.

TIPS FOR SUCCESS WITH RESIN CLAY

- To smooth the surface of resin clay, you can use water, rubbing alcohol or Aves Safety Solvent applied with a brush or squeeze bottle and smoothed with your fingers.

- When covering a large surface with resin clay, start by adding smaller areas and embed objects as you go, especially if you think you will be working for a total of 3 hours or more (at which time your clay will begin to set up, making embedding impossible).

MAKING COLLAGE AND JEWELRY ELEMENTS

I am assuming that you are busy making silicone press molds from any interesting object you come across. Good for you! Press resin clay into your molds and you can further embellish your molded pieces with beads, charms or other small items that will look great in your art or hanging from a chain around your neck or dangling from your lovely ears.

When using silicone molds with resin clay, wait for about an hour and a half after mixing, then press the clay into the mold.

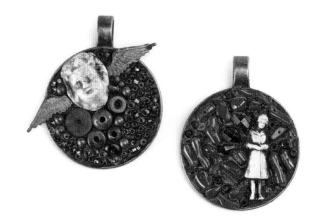

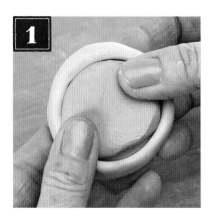

Put the clay into your mold and press to ensure an impression is made.

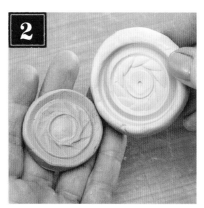

Carefully remove the clay before it sets.

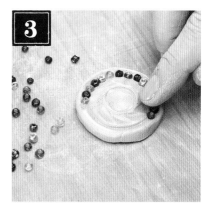

Add beads or embellish as desired, then let the clay cure thoroughly.

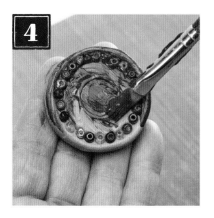

Brush with a dark acrylic glaze.

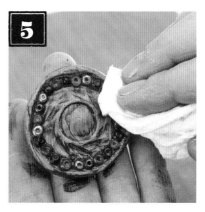

Wipe off any excess glaze.

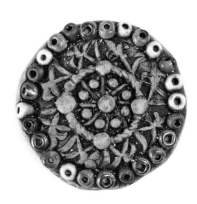

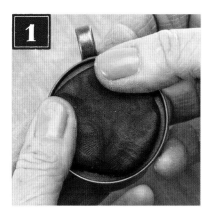

1

Press resin clay into a bezel to begin a piece of jewelry.

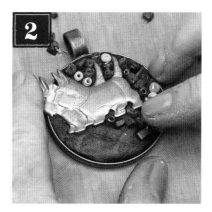

2

Add embellishments to the clay and let it cure.

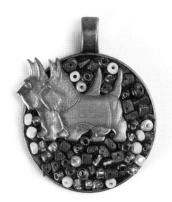

1

When working with tiny beads, pick them up with masking tape.

2

Press the tape with the beads into the resin clay.

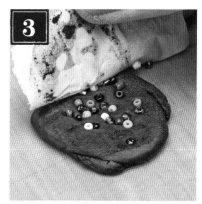

3

Remove the tape, and the beads should remain in the clay.

RESIN CLAY BEAD TIPS

When making beads from your resin clay, let them sit for at least an hour or more to harden a bit. Then shape and poke a hole all the way through the bead and let it harden on the skewer. Twist the beads occasionally so they don't adhere to the skewer.

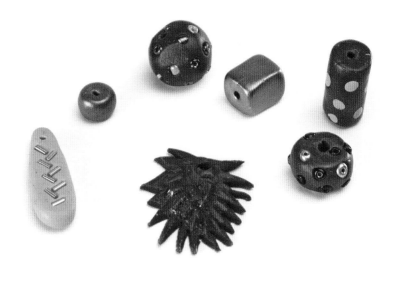

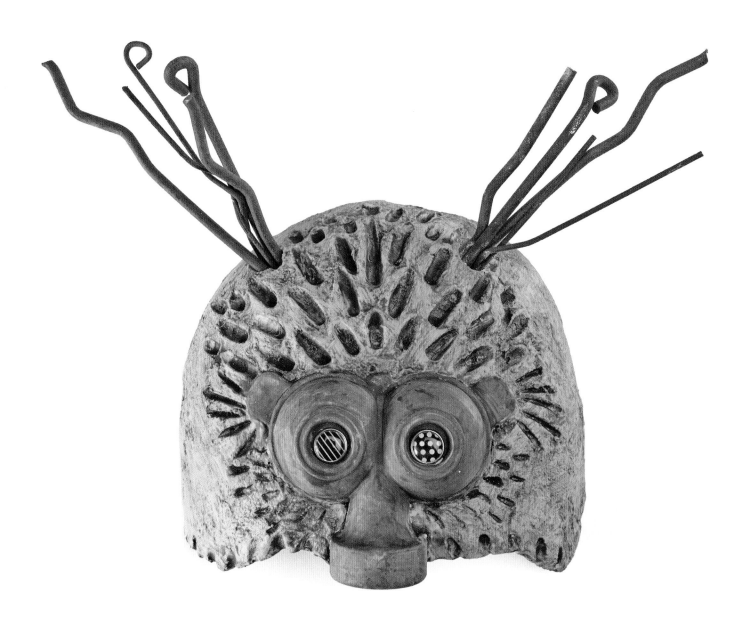

CUKOO BIRD ▪ PATRICIA CHAPMAN
ClayShay over mask form, painted, with found objects added.

CLAYSHAY ⑭

All it takes is a little added water and your own wild imagination to make magic with this stellar powdered clay/paper mache hybrid. Mixed to a thin, slip-like consistency, ClayShay can be used as a casting medium with either press molds or three-dimensional block molds. ClayShay slip can also be used to coat fabric or objects, and voilà—you have turned those objects into a solidified clay piece! Mix slightly thicker than slip consistency to create stenciled reliefs. Mixed to a thick, frosting-like consistency, it can be smoothed over foam, foil or cardboard armatures. Mixed to a very thick, claylike density, it is a wonderful modeling medium.

All this versatility and ClayShay is also nontoxic, has zero-percent shrinkage, is lightweight, durable, easy to clean up, has a crazy-long shelf life, and can be carved, filed, sanded or painted after setting.

MATERIALS USED IN THIS CHAPTER:

acrylic paints

brushes

ClayShay

craft or utility knife

drawing and carbon paper

Dremel tool with carving bits (or wood carving tools)

found objects

gessoed board

glue

mask form, paper mache

metal leaf

plastic wrap

posterboard and tape

sand paper (optional)

small balloons

spatula or modeling tool

twist tie or string

MIXING TIPS

- To mix ClayShay to a thin slip consistency for casting or dipping fabrics or objects, use approximately 1 part water to 2 parts ClayShay.

- To mix to a medium-thick consistency for smoothing over armatures, use 1 part water to 4 parts ClayShay.

- For an extra-thick consistency for modeling, use 1 part water to 5 parts ClayShay.

You can vary these ratios according to your own preferences and the atmospheric conditions where you live.

CARVING

After clay made with ClayShay has dried, you can carve any design, pattern or texture into the surface. A Dremel tool with a carving bit provides terrific control, making it easier to carve. Paint a board with gesso and build a small box out of cardboard around the edges. Pour a mix of ClayShay over the board to make a flat plaque for carving. To make your carvings really stand out, paint your plaque or figure, let it dry and then paint a glaze of a contrasting color over the basecoat, wiping off all the glaze except for what remains in the recesses of the carved areas.

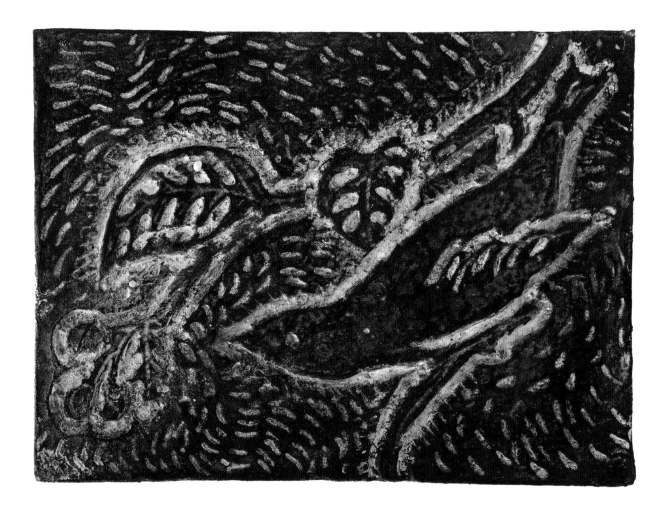

BIRDY ▪ PATRICIA CHAPMAN
Slab of ClayShay, carved, painted with light glaze over dark paint.

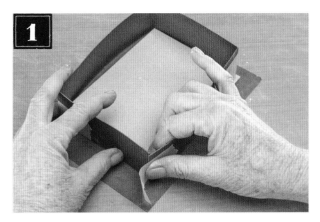

Tape together a box made of posterboard, and tape the box to a gessoed board.

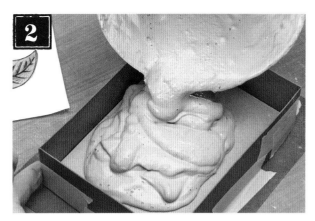

Mix ClayShay to a pourable consistency and pour over the gessoed board.

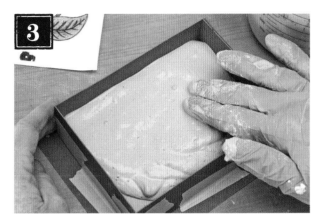

Tap or shake to smooth the surface of the poured clay. Allow it to dry thoroughly (this usually takes 1–2 days). Remove the box by tearing the posterboard.

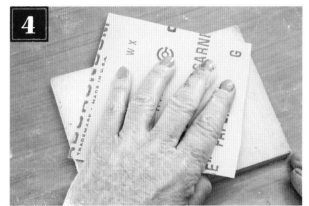

Sand the surface of the clay if desired.

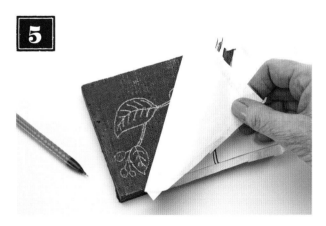

Paint the clay with a dark-colored paint, then transfer a drawing onto the surface using carbon paper.

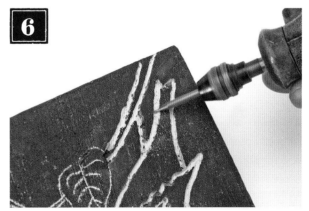

Carve over the transferred lines using a Dremel tool or a sharp, metal-tipped wood or ceramics carving tool.

MODELING

For modeling, you will want to mix the ClayShay to an extra-thick consistency so that it feels like … well, like clay! If you are just modeling small figures, you will not need an armature, but a wide base to support your figure will be necessary. If you want to model something much larger, you will need to make an armature to support the clay. After thoroughly drying, your modeled pieces can be painted and finished any way you want.

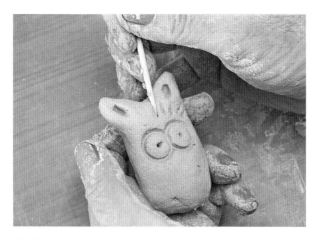

Mold into shapes, making marks in the clay.

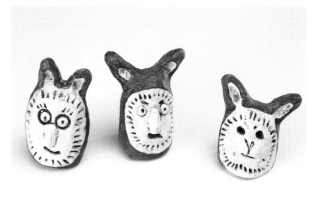

Painted and dark acrylic wash applied.

STENCILLING

Working with a buttery consistency of clay, you can spread it over a stencil for a raised stencil look. You can even stencil it on Plexiglas, but to make it permanent you need to spray it with a gloss acrylic varnish. It sticks well to canvas and panel.

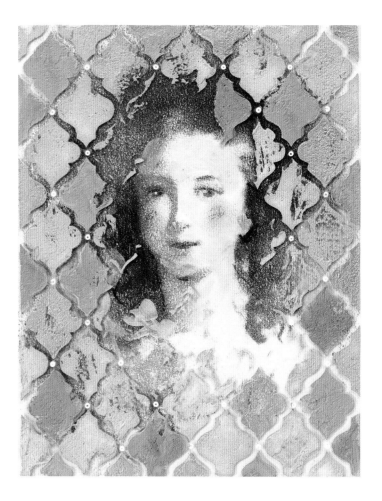

A buttery consistency of ClayShay was applied through a stencil onto Plexiglas; painted and round beads were added. The piece was sprayed with a gloss acrylic varnish and placed on top of an image transfer created with Crystal Clear. (See my book *Image Transfer Workshop* to learn more about transfers.)

DIPPING

Mix up a thin slip consistency of ClayShay and dip or pour the mixture over any object or fabric. After it dries, you have completely changed the visual nature of these dipped pieces, essentially changing them into clay objects that can be painted or finished or just left in their natural clay state. A whole assemblage of objects finished this way could be used in a mixed-media art piece, or just one or two items could be used in a collage.

Find an object that you want to dip (in this case, a doll dress) and dip it into the thin slip mixture.

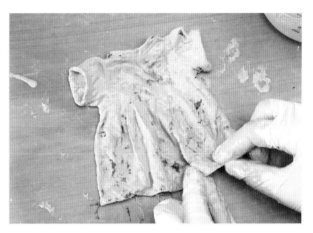

Position the object how you want it to look when dry, and then let the object dry.

Applying paint and glaze will change the look. This piece was sprayed with metallic silver paint and then brushed with a dark acrylic glaze.

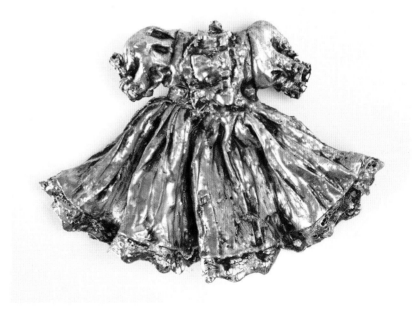

MAKING MASKS

You can cut blank masks (found online or in art supply stores) to any shape you want, smooth on a thick mixture of ClayShay and add textures and embellish with interesting found objects to create one-of-a-kind masks. Beads, yarn, wire, small objects, broken jewelry pieces, buttons and feathers (the list goes on and on) all make delightful additions to your masks.

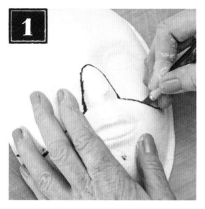

1 Draw cut lines on a blank paper mache mask and cut. Make holes to add embellishments if necessary.

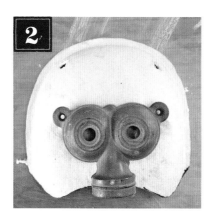

2 Attach found objects (like this old sprinkler component) using a suitable glue such as an epoxy adhesive.

3 Mix ClayShay to a thick frosting consistency and spread it on with a spatula or a clay modeling tool.

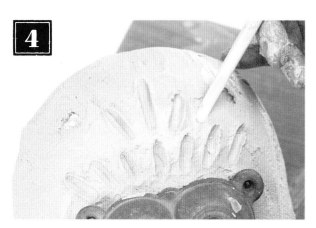

4 Make marks in the clay using a moistened clay modeling tool. Let the clay dry thoroughly.

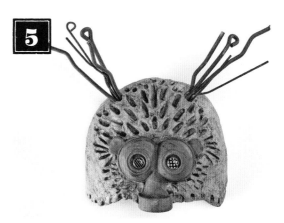

5 Paint and add embellishments.

FORMING BALLOON BOWLS

These bowls are fun, beautiful and easy to make. The bowl will not be waterproof, but it will be a beautiful way to display any dry objects. It is more dramatic to paint the inside of the bowl a different contrasting color from the outside of the bowl.

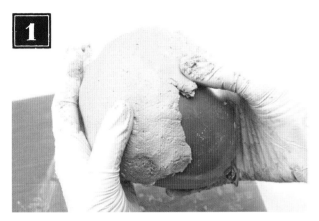

Apply a thick mixture of ClayShay to the bottom two-thirds of a small, inflated balloon, leaving an uneven, thinned-out edge.

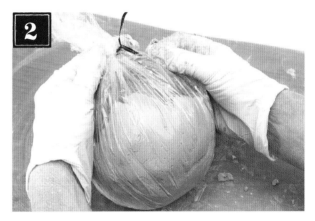

Wrap plastic wrap around the balloon and tie it closed with a twist tie or string. Creases will happen; arrange as desired.

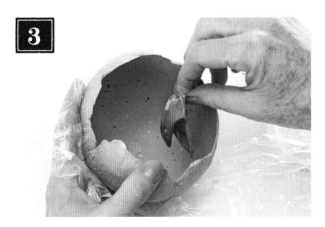

When the clay is thoroughly dry, peel off the plastic and pop the balloon to reveal the bowl.

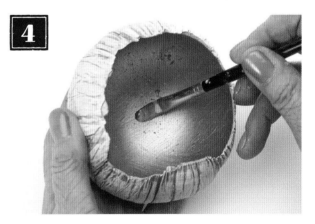

Paint or brush the outside with an acrylic glaze, and use a contrasting paint (like the metallic gold paint used here) for the inside of the bowl.

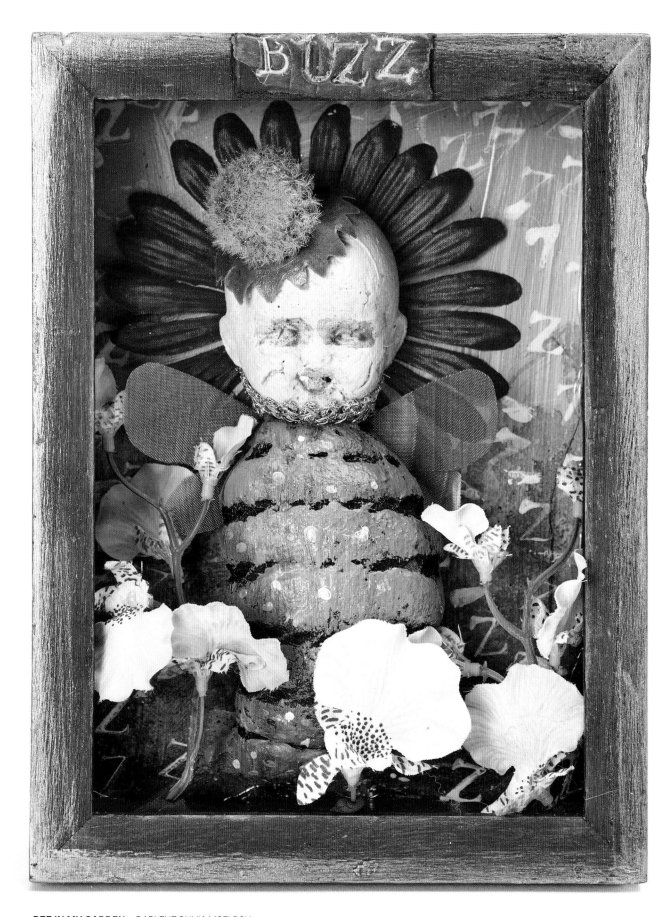

BEE IN MY GARDEN ▪ DARLENE OLIVIA MCELROY

Cast paper mache doll head glued to paper mache bee body placed in deep box with collage elements.

PAPER MACHE (15)

Did you ever play with paper mache as a kid? These days paper mache has become a super-versatile, hip and cool medium to consider using for your mixed-media art. Powdered paper mache mixes up easily with water, and since it is self-adhesive, it can be molded onto any armature or existing nonslick object to create beautifully detailed sculptures. While the paper mache surface is still wet, it can be stamped or marked to add texture, and once it has dried, it can be sanded, painted, drilled or carved into. Press paper mache into a silicone press mold and let it dry, and the result will be a piece with an interestingly rustic texture. When dry, paper mache is extremely hard and durable, yet quite lightweight. Mix up a batch and try it.

MATERIALS USED IN THIS CHAPTER:

acrylic paint and acrylic glaze

aluminum foil

background surface

brushes

clear resin

craft knife

embellishments

epoxy glue

paper towels or rags

powdered paper mache

resin cast of wings

Scrabble letters

silicone mold of doll head

small cardboard box

small wood block

stamps

store-bought paper mache heart

PAPER MACHE ON PAPER MACHE

At craft supply stores and online you will find a vast array of premade paper mache forms that come in all kinds of different shapes. These rigid, kraft paper–covered shapes can be easily cut and altered, and they make a great base for covering with a powdered paper mache mixed with water to a thick claylike consistency. While the paper mache is still wet, it can be stamped to create some wonderful surface textures and embellishments, and letters can be added. Model facial features onto a mask form, model a fantasy dress onto a dress form, or give your heart wings!

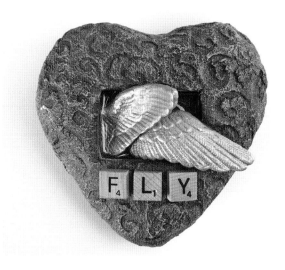

1

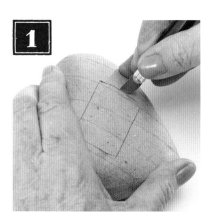

Cut a square opening in a store-bought paper mache heart.

2

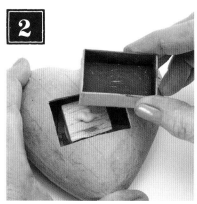

Glue a wood block to the bottom inside the opening. Then glue a small box onto the wood block to fill the opening.

3

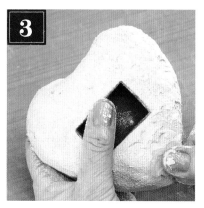

Add powdered paper mache (mixed with water to a thick, claylike consistency) to the heart and stamp on a pattern.

4

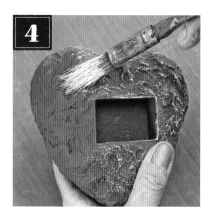

Once it's dry, cover the heart with acrylic paint and let dry. Then drybrush to highlight raised areas. Let it dry.

5

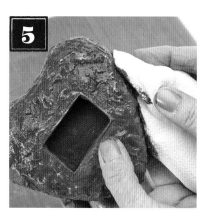

Mix a dark color of acrylic paint with acrylic glaze medium. Brush on and wipe off excess to leave a dark glaze in recessed areas.

6

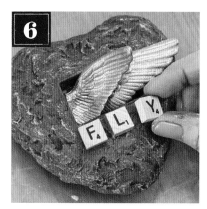

Pour some clear resin or epoxy glue into the small box and place the wings in the box. Adhere letters with premium white glue, E6000 or epoxy glue.

CAST AND SHAPED PAPER MACHE

Cast a head, then mold a body over aluminum foil as shown in the chapters on casting and aluminum foil armatures. Create a scene and add your character to it to create a visual story. The paper mache takes paint wonderfully, so it is a real pleasure to work with.

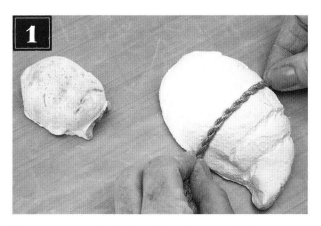

Cast a paper mache doll head in a silicone mold. Then mold a paper mache bee body over aluminum foil and add marks.

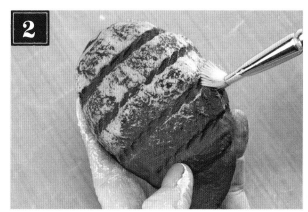

Once it's dry, add an allover color. Once that is dry, add another color over it for dimension and texture.

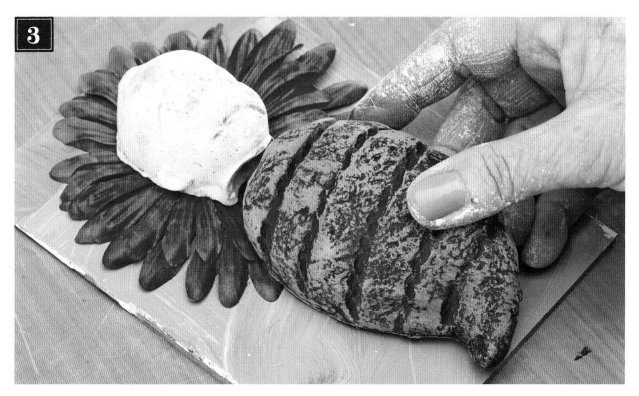

Glue the doll to a background and add embellishments to create your visual story.

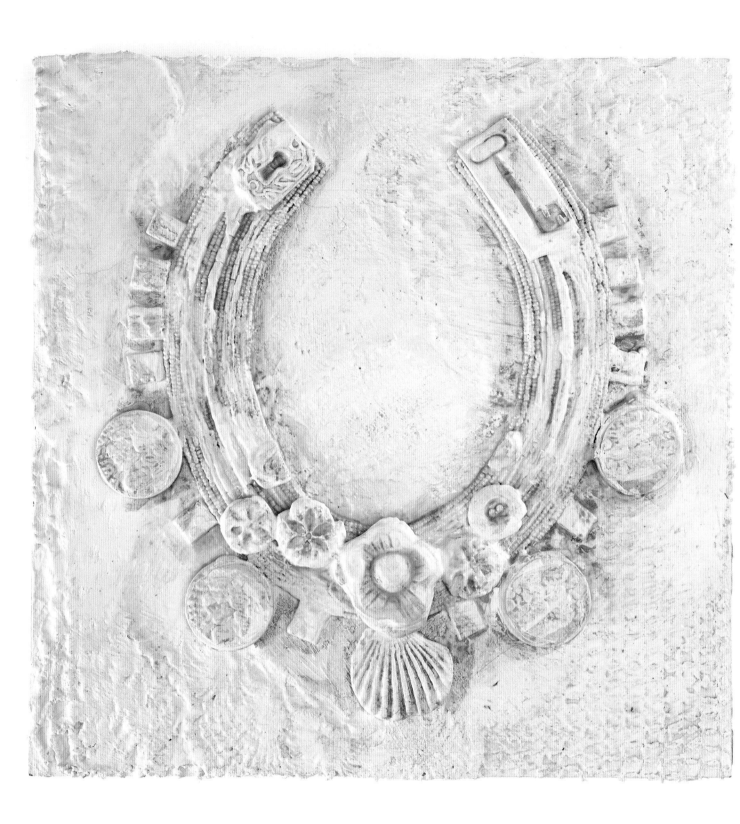

NECKLACE OF A LOST CIVILIZATION ▪ DARLENE OLIVIA MCELROY
Collage element and cast objects adhered to a lace-covered panel and coated with plaster of Paris; a tinted wash of acrylic finished the look.

PLASTER OF PARIS & PLASTER GAUZE

16

Ooh la la—I feel so French when I work with plaster of Paris! Swirl it, trowel it, cast it, sing French songs! Or pretend you are a doctor as you make casts with the plaster-coated gauze. Wrap it, cut it, shape it! This product has been in use for centuries for both functional and creative purposes. It is fast-drying and sturdy when sealed. You can paint directly on the plaster, although you will find it very absorbent. Or you can coat it with a polymer matte medium before painting (this is a big help if you are planning to paint or stain the plaster).

Several of these techniques also work with joint compound and Venetian plaster.

PLASTER TIPS

- Wear a face mask as a health precaution when working with plaster and powdered pigments.
- There are so many ways to cast with plaster. See the chapters on casting, molding and armatures for more ideas.
- The flexibility of plaster gauze gives you a variety of options to play with. Add paint, cut up, collage, sew or combine with other techniques in this book.

MATERIALS USED IN THIS CHAPTER:

board, canvas or wood

bubble wrap

ceramic or plasticine clay

cooking spray

doilies and lace

frames

gessoed board

glue

mark-making tools

objects to cover or dip

paint or gold leaf

plaster gauze

plaster of Paris

plastic sheet

rolling pin or brayer

sandpaper

silicone mold

stamps

stiff brush

DIPPING IN PLASTER OF PARIS

Do you have some old fabric flowers, crocheted items, clothes, knickknacks or perhaps some lace, cut paper and cardboard lying around? Instead of tossing them, dip them in plaster of Paris and make a piece of art.

A thinner consistency of plaster works best for dipping (about the consistency of cream). Wear disposable gloves; dipping can get messy! Please note that while plaster sets up quickly (no more than half an hour), it will take a full day or more to dry completely.

COLORING AND SEALING TIPS

- You can use both acrylic paint and powdered pigments to tint plaster of Paris. If using powdered pigments, mix them with the plaster before adding warm water. If adding acrylic paint, add colder water to the plaster and then your paint. This gives you enough time to mix well before pouring and the plaster starts curing.

- You can seal with a variety of products such as shellac, GAC 800 by Golden, resin or a polyurethane sealant. These are shiny but can be dulled with sanding or with a matte spray finish.

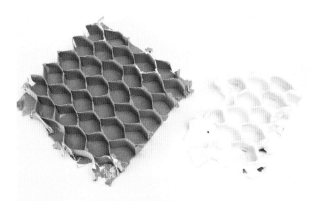

Dipped corrugated cardboard.

Dipped cutout paper.

Dipped embossed wallpaper.

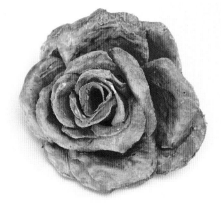

Dipped fabric flower colored with a mix of red acrylic paint and acrylic glazing medium brushed on and excess wiped off.

Choose fabric flowers for dipping.

Dip the flowers into the plaster.

Set the flowers on a nonstick surface to dry.

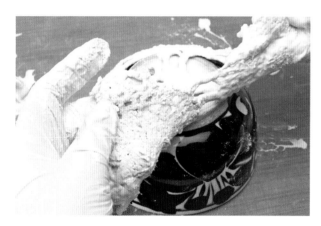

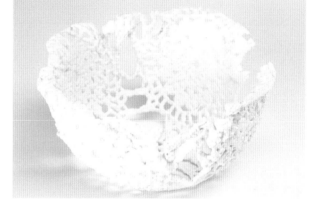

Dip a doily in plaster, then lay it over a form (such as the ceramic bowl shown) to dry.

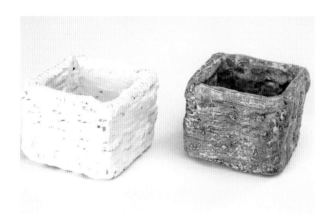

Paint a plaster-covered basket with a dark acrylic paint and then drybrush with a lighter color of acrylic paint.

Gold accents added to a plaster-dipped sheep.

PLASTER PLUS MORE FOR BACKGROUNDS

We all have bubble wrap and scrap lace or textured fabric somewhere in our house or studio, so let's put them to use by combining them with plaster to create dramatic backgrounds. Here are just a few easy ideas to get you started.

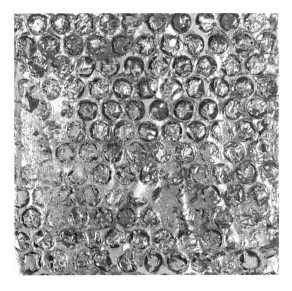

1

Lay bubble wrap on wet plaster that has been applied to a board.

2

When dry, pull the bubble wrap off.

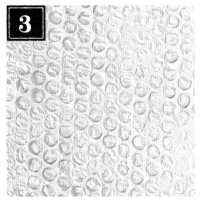

3

Sand the surface very lightly after 24–48 hours. Then add paint or gold leaf (as shown above).

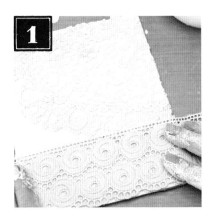

1

Glue lace and doilies to the surface of a gessoed board.

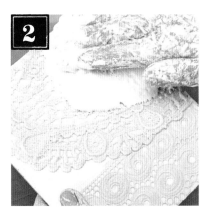

2

Apply plaster over it.

3

When dry, it can be painted or left white.

100

FRAME CASTING WITH PLASTER OF PARIS

Plaster can make not only the background for art but the art itself. All you need are a thrift store frame, traditional clay, stamps or other mark makers, and your plaster to make a beautiful, framed, cast plaster masterpiece.

1 Roll out a slab of clay.

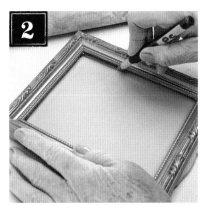

2 Mark and trim the slab to fit your frame.

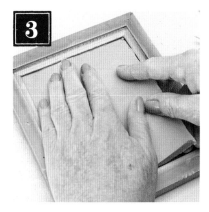

3 Apply the clay inside the back of the frame. Make sure the clay presses firmly against the inside edges of the frame.

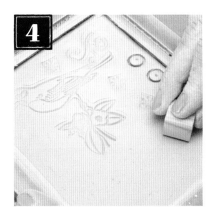

4 Make marks on the clay with stamps or any kind of mark-making tools.

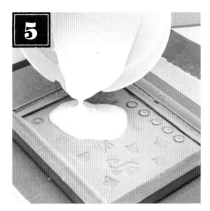

5 Pour plaster of a soupy consistency onto the clay and allow it to dry for anywhere from half an hour to a couple of hours. Do not let the clay dry to the point where it is no longer pliable.

6 Flip the frame over and peel off the clay slab to reveal your framed plaster artwork. Make sure the plaster is completely dry before you paint or stain it, or just leave it au naturel.

MAKING RELIEFS WITH PLASTER GAUZE

To create a sunken relief, just coat your object of choice with cooking spray and start layering strips of wet plaster gauze onto it, pressing the gauze against the object with a stiff brush as you go. Pry out your object after the plaster sets.

A raised relief is made by layering wet strips of plaster gauze in a silicone mold, pressing with a stiff brush into all the nooks and crannies of your mold, and removing the plaster after setting.

For a sunken relief, coat an object with cooking spray first.

Apply wet plaster gauze in three layers, smoothing them out as you go and pressing the gauze down with a stiff brush.

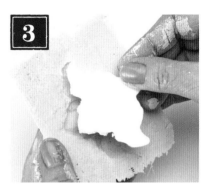

Turn it over after letting it harden for about an hour, then pry the object out of the set plaster gauze.

SETTING UP AND SMOOTHING OUT

Warm water helps the plaster gauze set up faster and makes it easier to smooth out the plaster.

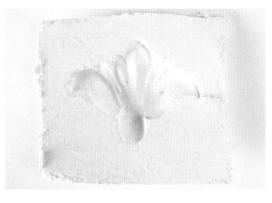

Impression in plaster gauze with details.

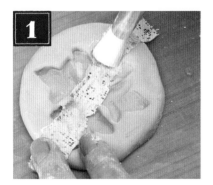

For a raised relief, apply gauze to a silicone mold (pressing with a stiff brush).

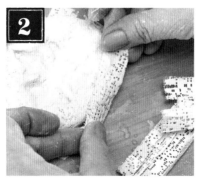

Apply three layers of gauze, smoothing it out as you go. Let it harden.

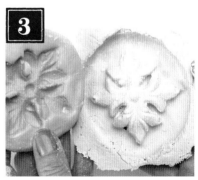

Remove it from the mold when set and trim if desired.

Sign up for our FREE e-newsletter at CreateMixedMedia.com.

WRAPPING AN OBJECT TO LOOK OLD OR NEW

Cast or wrap an everyday object in plaster gauze, then paint and embellish it to make it looked aged and like an archeological find, or to give it an entirely new and different look.

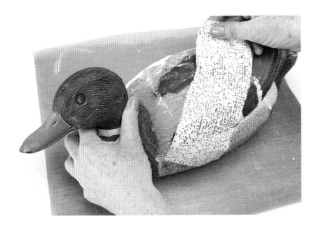

Wrap your object in plaster gauze.

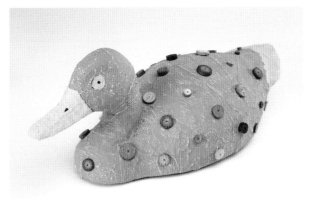

Paint and embellish as desired.

MAKING PLASTER GAUZE PAGES

Use plaster gauze to make book art pages with a textured twist. Keep adding strips of wet gauze on top of one another and smoothing until you achieve the thickness desired.

TEXTURING CANVASSES

Want a fast way to give a canvas texture? Just wrap it with plaster gauze, creating peaks and valleys on the surface. When it is painted, you can add drybrushing to highlight the texture.

Lay two layers of wet gauze down on plastic.

Smooth the layers and let it dry.

Cut out a window (if desired), then paint the book page.

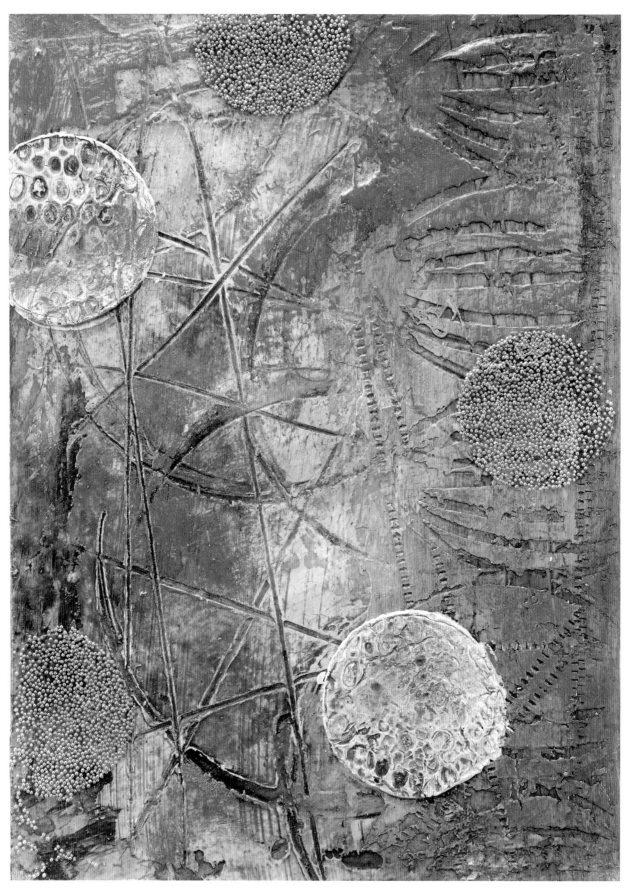

ALIEN MOONSCAPE ▪ DARLENE OLIVIA MCELROY
Carved and stamped Venetian plaster with layers of colored acrylic glazes.

VENETIAN PLASTER 17

Venetian plaster reminds me of all the old frescoes and wall treatments in Europe. It consists of plaster mixed with marble dust and has a fragile matte finish until finishing. Burnishing will create a highly polished, rock-hard, marble-like finish. It can be painted, carved into, shaped, sanded, layered and so much more.

MATERIALS USED IN THIS CHAPTER:

acrylic paint

canvas or burlap

mark-making tools

polymer medium

sandpaper

stamps

stencils

transfers

Venetian plaster

VENETIAN PLASTER TIPS

- VersaBond and joint compound are very similar to Venetian plaster, and the same applications can be done to them.

- Add Venetian plaster to your acrylic paint to give it more body for an impasto look instead of using gels and pastes to thicken it. This will save you money that you can spend on more art supplies. This trick is great for palette knife paintings and scraping color over color. Try scraping tone over tone (like a red over a pink), or just go crazy with your colors.

APPLYING AND COLORING

Be sure to apply thin layers of Venetian plaster, letting them dry between applications. Plaster applied thickly will crack and be less durable.

Venetian plaster comes in colors, but if you buy the neutral base, you can tint it with acrylic paint (mixing thoroughly). Your surface will be absorbent and the paint will absorb into it, changing the color. You can then carve or scratch into the surface, revealing the underlying color, or you can seal the surface with a coat of matte polymer medium.

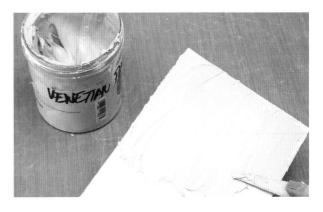

Embedded paper in layers of tinted Venetian plaster.

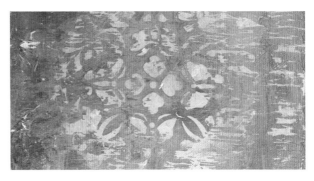

Stencil covered with colored Venetian plaster and sanded back.

Stamping, scratching and layered Venetian plaster stencils.

Texture added to wet Venetian plaster and painted when dry.

Venetian plaster added to acrylics for impasto look.

Carved Venetian plaster.

VENETIAN PLASTER CRACKLE

Spread a thin layer of Venetian plaster on either canvas or burlap, and stamp designs into the surface. Let the plaster dry thoroughly and crumple the plaster-covered fabric into as many creases as possible. Apply a colored wash that will seep into and accentuate the cracks in the crumpled plaster.

Venetian plaster crackle on canvas.

Venetian plaster crackle on burlap.

ADDING TRANSFERS

Any scratches or marks will show when you put your transfer down, which will give it an aged look if you sand it after it dries. If you want a less aged look, make sure your plaster is completely smooth before you apply your transfer. My favorite transfer is a Crystal Clear transfer, but you can also use waterslide decals, Citra Solv transfers, blender pens or wet gel transfers. For more on image transfers, check out my book *Image Transfer Workshop*.

Sanded waterslide decal with paint applied to top.

PARTY CROWN ▪ DARLENE OLIVIA MCELROY
Fiber paste on stiff netting with fiber paste stencil, rhinestones, gold paint and glitter.

FIBER PASTE (18)

Kind of like clay but kind of not, fiber paste has the feel of a thick slurry of grouted clay, but the dried result is more like handmade paper. In addition, you can cut it, sew it and print on it. It is easy to tint using acrylic paints, and things adhere well to it because of its polymer base. It does take time to dry (sometimes overnight).

MATERIALS USED IN THIS CHAPTER:

acrylic paint and brush

cake decorating applicator

embellishments

fiber paste

glue

heavy netting

palette knife

plastic sheet

scissors

soft gel

stencils

tape

texture or embossing plate

MAKING A FIBER PASTE SHEET (OR SKIN)

Fiber paste sheets or skins can be left natural, tinted or painted. You can cut them into shapes, make mosaics out of them, create deconstructed stencils and even print on them.

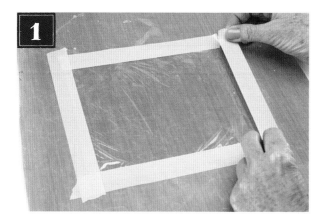

Tape plastic wrap to your work surface or use a polypropylene cutting board as your surface.

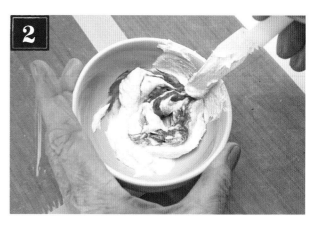

Add a small amount of acrylic paint to your fiber paste and mix thoroughly to tint.

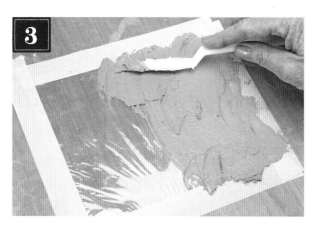

Spread fiber paste on the plastic wrap, making sure it goes over the tape's edge.

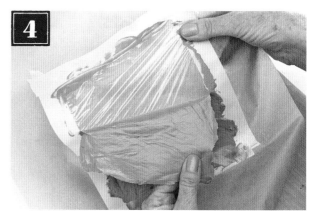

When completely dry, use the tape to help peel off the paste.

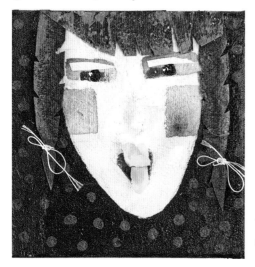

The fiber paste skin can be cut into shapes and painted with acrylics or watercolor.

DECONSTRUCTING STENCILS

Apply fiber paste through a stencil onto a plastic sheet. When this dries, you have a stencil you can lift off the plastic and rearrange to make a new stencil or a combination of stencils.

Once the fiber paste is removed from the plastic, glue it with soft gel.

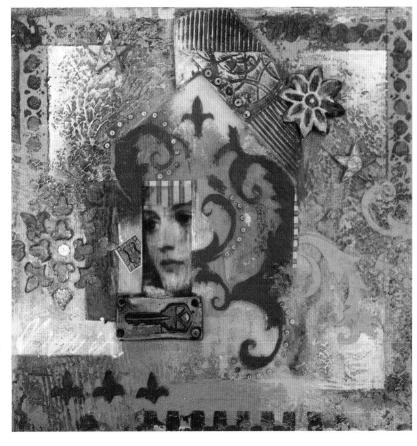

This sample piece features painted and reconfigured fiber paste stencils.

EMBOSSING

You can emboss all kinds of patterns and textures into fiber paste. You can wait until the paste has partially set up and then emboss into it, or you can spread it over a plastic texture plate and let it dry. Because the fiber paste dries against a slick surface, it will look slick on the embossed side.

Apply fiber paste on an embossing or texture plate and let it dry.

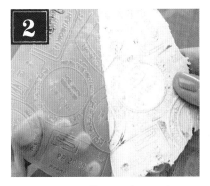

When dry, peel off. Any color residue on the plate transfers to the dried paste.

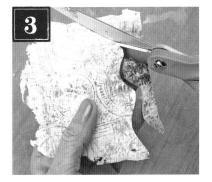

Cut up and use the embossed fiber paste as a collage element in your art.

APPLYING ON ARTWORK

You can either spread fiber paste directly on art for texture or spread it on plastic as we have done here. When it dries peel it off and place it where you want on the art and glue it down with soft gel.

Apply fiber paste in broad strokes to plastic. Let it dry.

Peel the dried fiber paste off your work surface. Rust it with a two-part compound or as desired.

Glue the piece (cutting if necessary) with soft gel to add dimension to a painting.

FIBER PASTE FILIGREE AND ORNAMENTATION

Fiber paste is just the right consistency for using with a cake decorating applicator. If you want a thinner consistency, mix with distilled water. With a permanent marker, create your design on a piece of aluminum foil or place a drawing under clear plastic. Fill a cake decorating applicator with fiber paste, having selected your desired nozzle first. Use this to create a filigree, add ornamental elements for your art, or even try making a coiled pot.

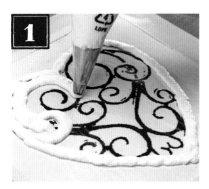

Fill a cake decorating applicator with fiber paste and go over your design.

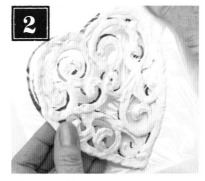

Lift up the fiber paste once it has dried and apply it to your artwork.

BUILDING A FREESTANDING STRUCTURE

I believe there is a bit of royalty in all of us, so let's make ourselves a crown so we can hold court.

Fold heavy netting (from a fabric store) and cut it into peaks.

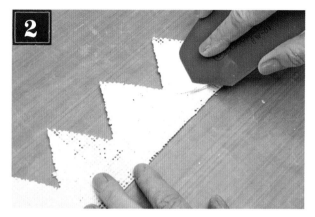

Flatten the netting and cover it with fiber paste. Let it dry.

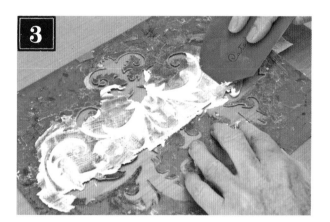

Stencil a layer of fiber paste onto your crown.

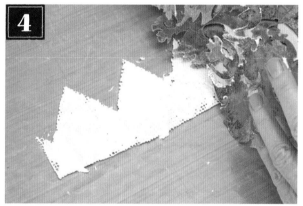

Remove the stencil and let the fiber paste dry.

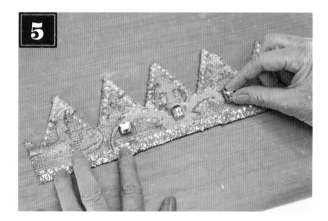

Paint, stain and add embellishments to make it uniquely your own.

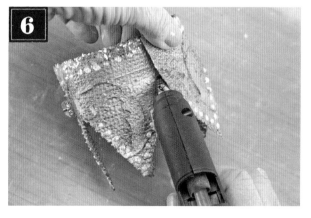

Connect the ends and glue together.

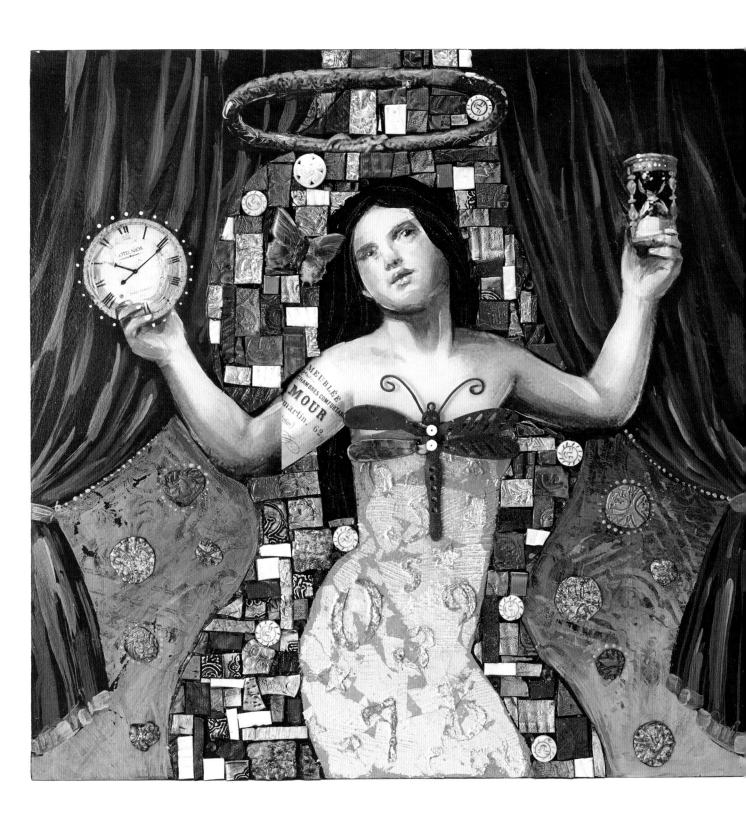

TIME DIVA ▪ DARLENE OLIVIA MCELROY
Mosaic of embossed plastic strips added to painting.

PLASTIC MODELING PELLETS & STRIPS ⑲

I believe we can't be an artist without having the soul of an adventurer, a scientist and an alchemist. Melting plastic and changing its shape fulfills those parts of me. Plastic modeling pellets and strips allow you to create dimensional elements, mosaic tiles, jewelry beads and more. Although the plastic strips come in a variety of colors and metallics, they can also be gloriously colored with alcohol inks. You can cut them with scissors, heat them to your canvas and even reheat them if you want to try a different technique on them.

Be careful working with hot plastic, and use the same caution you would use with anything hot. Use tweezers and wait until the plastic has cooled to a warm but still malleable temperature.

Note: Do not use a heat gun on a plastic working surface or use a rubber stamp on the plastic strips if they are too hot as the plastic will stick to the rubber.

..
MATERIALS USED IN THIS CHAPTER:

acrylic paint

bezel

clear sealant

cup of hot water

E6000 glue

fork and cookie cutters

hammer and punch

heat gun

metal leaf crumbles

molds

Pearl Ex powdered pigment

plastic modeling pellets and plastic strips

scissors

skewer

slick surface (plastic, or shiny side of butcher paper)

stamps

tweezers

vegetable oil

MAKING PLASTIC PELLETS PLIABLE

There are several ways to make plastic pellets pliable: in a heated skillet, with a heat gun or with hot water. We prefer putting the pellets in a cup of hot water. They will stick to each other, making a ball. While they are warm (not hot), you can roll them out, press them into a mold, shape them or stamp them. They first appear transparent but turn white as they set up. They can be reheated and reworked. They cool quickly, so you must work fast or reheat. Paint them with acrylics when finished. You can reheat them to stick to your surface or just use E6000 glue.

Add the pellets to a cup or bowl of hot water.

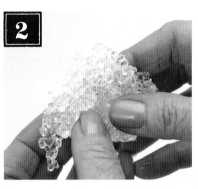

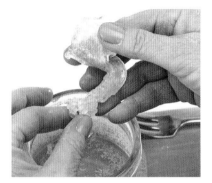

Remove the pellets, which should be sticking to each other, and knead them together.

MOLDING PELLETS

Store-bought or homemade silicone molds work well for molding plastic as the plastic releases easily from the silicone. Depending on your mold, you may have to coat it with a mold release or cooking spray.

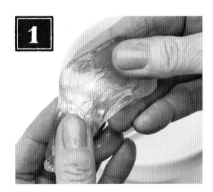

Knead the heated pellets.

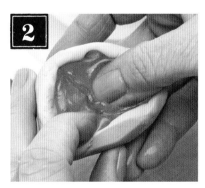

Press into a mold while still warm and pliable.

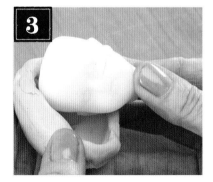

Once it's cool, release the shaped plastic from the mold.

STAMPING PELLETS

Melted pellets take stamping well but because they cure to a white color, you won't see the stamp marks until you paint them. Try different techniques like drybrushing, staining, color rubs or metal leaf to see which you like best.

Shape the heated pellets into the shape you want.

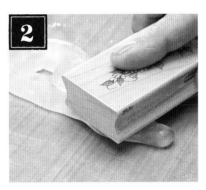

Stamp and let set.

Add paint.

PLASTIC CABOCHON WITH IMAGE TRANSFER

It's super easy to form a cabochon inside a bezel with plastic pellets.

Roll melted pellets into a ball and place the ball into a bezel, smoothing and flattening with vegetable-oiled fingers. Allow the plastic to set completely and remove the cabochon from the bezel.

Print a graphic image onto transfer paper and apply it to the cabochon, trimming the edges after it is dry.

Brush on a clear sealant (such as a clear polymer medium) and allow it to dry. Glue the cabochon into the bezel with E6000 glue.

FORMING PELLETS INTO BEADS

Making beads from plastic pellets to string together for a lightweight bracelet or necklace is as easy as rolling the melted pellets into a pliable ball and poking a hole into it with a skewer. You can color your melted pellets by mixing in acrylic paint, alcohol ink or Pearl Ex powdered pigments, or add sparkle by mixing in glitter. You can also reheat your beads one by one while they are still on the skewer, roll them in metal leaf crumbles and wipe off the excess to create shiny "metal" beads.

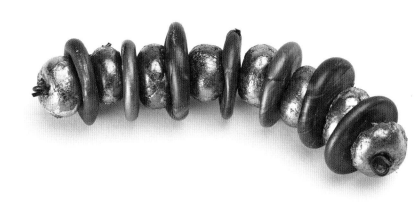

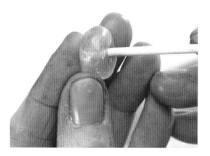

Poke a skewer through a pliable ball of melted pellets to make a hole, creating a bead. Let the beads cure on the skewer before removing the skewer.

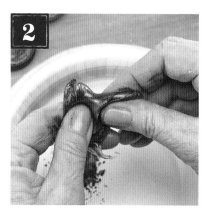

Mix in Pearl Ex powder, acrylic paint or alcohol inks to color the pellets.

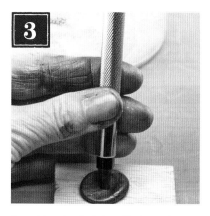

Form the plastic into a flattened disk and use a hammer and punch to create a hole after the bead sets.

To color a bead with metal leaf, start by reheating your bead on the skewer.

Remove the reheated bead from the skewer and roll it in metal leaf crumbles.

Rub off the excess leafing and return the bead to the skewer.

STAMPING PLASTIC STRIPS

Stamp once or multiple times on heated strips. These can be heated the same as the plastic pellets. The heat gun can make the strips too hot and gooey, so you might have to wait until they cool off a bit before stamping or molding. I prefer putting my strips in a shallow bowl of hot water, taking them out with tweezers and placing them on an art surface. You can also place them on butcher paper (the shiny side), stamp them and then glue them onto your art.

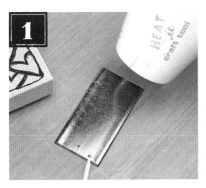

Heat the strip.

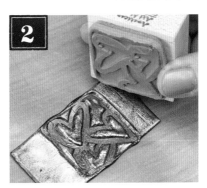

Stamp on heated strips.

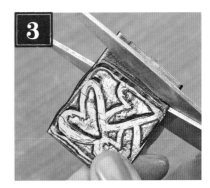

Trim off the unstamped area.

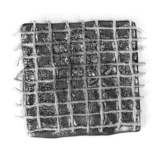

Plastic strips can be left natural or painted, or metal rub can be added.

CLEANING STAMPS

If the plastic is too hot, it may stick to your stamp if it is made of rubber. Let the stamp cool totally, then peel off the plastic.

MOLDING STRIPS

To create molded plastic, place your plastic strip face-down into a silicone mold and heat it with a heat gun until the plastic sinks down into the mold. Let it cool before removing it from the mold. While it is still hot you can pull pieces of the plastic out into string-like shapes. Trim edges after the plastic has cooled.

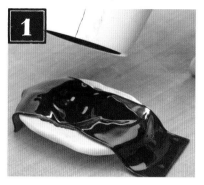

Lay a plastic strip on top of the mold and heat it. The strip will droop into the mold.

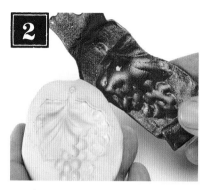

Let the plastic cool completely before removing.

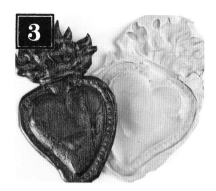

Trim off the excess plastic.

MELTING STRIPS TOGETHER

Melt multiple colored strips together with a heat gun, then take a long tonged fork and drag it across in one direction or multiple directions to form patterns before cutting the plastic into shapes. Having your metal cookie cutters in cold water before use makes the cutting easier.

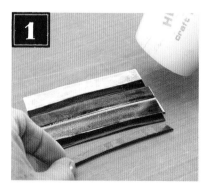

Melt multiple colored plastic strips together.

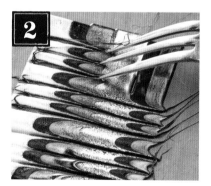

While the plastic is hot, comb it in one or both directions.

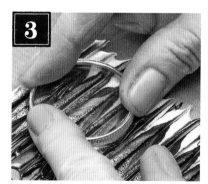

Cut into the hot combed strips with cookie cutters.

LAYERING STRIPS AND DIE CUTTING

Layer plastic strips and glue them together with either heat or E6000 glue to make unique and colorful creations. You can diffuse the shine with matte paint and gold rub to give your work an aged look.

Some of the heavier craft die-cut machines will cut the plastic strips. The dies come in a variety of patterns from scrolls and leaves to key and lock shapes and more. If you want to add texture to die-cut plastic, just heat it with a heat gun or hot water and add stamping. You can also layer them.

Overlap plastic strips, then bond them together with a heat gun.

Try putting your bonded plastic strips on top of an inverted glass bowl. Reheat the plastic to make a bowl shape or use flat as a collage element.

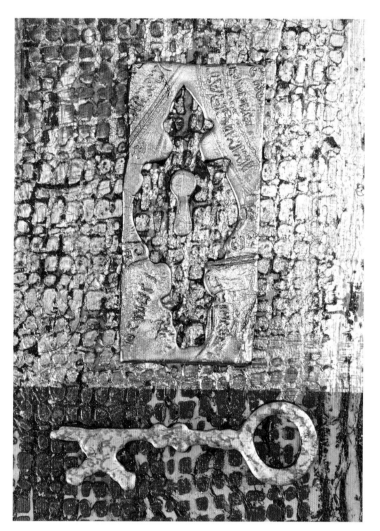

For this piece, a die-cut plastic strip is heated and embossed. When cool, it is glued to the background.

HOMEMADE CLAY RECIPES

Remember making clay out of flour and salt in kindergarten? Isn't it great that we are still playing with clay? We just had to share some of our favorite and funky DIY clay recipes with you. You can easily create all of these recipes in an afternoon and do your own comparison test. Most of these recipes can be made in just a few minutes. Several of them do need to be cooked, but this is the closest we will get to the stove in this lifetime.

You can add food coloring, acrylic paint or glitter to these clays to add color or sparkle, or simply paint and seal with a spray varnish after your clay projects have dried. Try antiquing with brown Briwax or drybrushing. It will take a few days for all of these clays to air-dry completely depending on the thickness of your projects. If you are not going to use all of the clay you make, be sure to wrap the unused portion in plastic and store it in a ziplock bag.

BAKING SODA CLAY

This is the brightest white clay of all these recipes. It holds details well and has a stiff enough body for modeling.

1 cup (237ml) baking soda

⅔ cup (158ml) warm water

½ cup (118ml) corn-starch

Mix the dry ingredients in a nonstick pan and then add water. Stir continuously over medium heat. When the mixture has started to resemble a soft dough, remove from the heat to cool for a few minutes. When it is cool enough to handle, knead the dough for about 5 minutes.

FOR BEST RESULTS

After making your homemade clay creations, let them dry on a nonstick pan or a sheet of freezer paper.

COLD PORCELAIN CLAY

Cold porcelain clay has a translucent quality. It is wonderful for modeling finely detailed pieces. It shrinks a bit when it dries.

¾ cup (177ml) Elmer's Glue-All

1 tsp. (5ml) liquid glycerin (found at a drugstore)

1 tsp. (5ml) cold cream (Pond's)

1 cup (237ml) cornstarch

½ cup (118ml) water

Mix white glue, water, cold cream and glycerin in a pan. Stir over medium heat until smooth. Add cornstarch and continue stirring. The mixture will become very stiff, and when it forms into a lump, it's done. Knead the clay for 5 minutes while it is still warm.

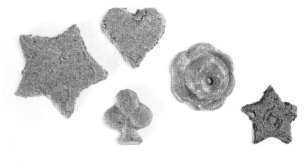

KOOL-AID CLAY

This clay is great to model with and holds detail when used in molds or stamping. The color of your clay will depend on what flavor of Kool-Aid you use. The color will lighten as it dries.

2 packets Kool-Aid

1 cup (237ml) flour

2 Tbsp. (30ml) cream of tartar

¼ cup (59ml) salt

1 Tbsp. (15ml) baby oil

1 cup (237ml) water

Mix dry ingredients in a pan. Add water and oil and stir until smooth. Cook over medium heat for 3 to 5 minutes. Keep stirring until the dough forms a lump. Knead for about 2 minutes.

SAWDUST CLAY

With this easy and rustic clay, you can form crude shapes, but it is impossible to get fine detail when stamping or modeling it. It does not cut cleanly and will be a bit challenging but works beautifully with molds. This clay dries super-hard with a grainy surface.

1 cup (237ml) sawdust

½ cup (118ml) flour

water

Mix together the sawdust and flour, then add water a little at a time until the mixture is stiff but still pliable. Add a bit more flour if the mixture is too crumbly. Knead for several minutes until it is elastic.

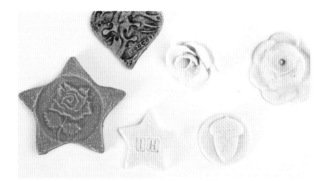

WHITE BREAD CLAY

This is a surprisingly lovely clay with very nice texture. You can model, stamp and mold this clay and it will hold great detail.

3 slices white bread

2 Tbsp. 30ml Elmer's Glue-All

Cut the crusts off the bread slices and tear the bread into small pieces in a bowl. Add the glue and mix with your hands (you may want to wear disposable gloves). Knead the mixture until it becomes smooth and pliable. Add more glue if the clay is too crumbly or more bread if it is too sticky.

PLAY DOUGH

This clay is very easy to work with and has a wonderfully pliable consistency. It is excellent for detailed modeling, stamping and using in press molds. It has slightly grainy texture when dry.

1¼ cup (296ml) flour

¼ cup (59ml) salt

1 cup (237ml) water

1½ Tbsp. (22ml) baby oil

½ tsp. (2.5ml) granulated alum (in the spice section in grocery stores)

Mix together the flour and salt. Put the water, baby oil and alum in a pot and bring it to a boil. Pour the boiling mixture into the dry ingredients and mix it all together. Knead for several minutes with more flour until it is no longer sticky.

RESOURCES

Art Supply or Hobby and Craft Stores
- acrylic gels, pastes and glazing liquids
- acrylic and craft paints
- canvas and art panels
- aluminum armature wire
- metal leaf
- Styrofoam
- floral foam
- stamps
- stencils
- brushes
- Creative Paperclay
- glues and adhesives
- Alumilite High Strength 3 mold making rubber
- Amazing Mold Putty
- Amazing Casting Resin
- Envirotex resin
- plaster of Paris
- plaster gauze
- alcohol inks
- Pearl Ex powders
- wood sticks for stirring/mixing
- Friendly Plastic modeling strips and modeling pellets
- wire mesh
- waxed linen thread

Hardware and Home Improvement
- Masonite
- MDF
- wood for bases
- Venetian plaster
- Dremel tool
- dowels
- drill
- wire cutters
- dark annealed steel wire
- chip brushes

Taxidermy Supplies and Glass Eyes
- mckenziesp.com
- vandykestaxidermy.com

BUNNY SURPRISE ▪ PATRICIA CHAPMAN
Hand-modeled and painted Critter Clay with embellishments and found objects.

Thrift Store
- frames
- buttons
- found objects

Apoxie Sculpt, Critter Clay, ClayShay, Paper mache
- avesstudio.com

Ceramic Clay
- clay or ceramic studio supply

ABOUT THE AUTHORS

DARLENE OLIVIA MCELROY

Born and raised in Southern California, Darlene comes from a family of artists and storytellers and was especially influenced by her grandfather, who was a well-known artist on Catalina Island. She creates work using transparent layers to reveal a depth that is hidden at first glance. Using neoclassical (or sometimes later) imagery to convey the fleeting quality of life, she brings people of the past back to life in her art, often in new and unexpected situations. Darlene shows her art in galleries nationally and internationally, teaches and is currently on the Creative Paperclay® design team. She lives in Santa Fe, New Mexico, with her husband and four dogs and is surrounded by wonderfully creative friends. Darlene is the author of *Image Transfer Workshop*, *Surface Treatment Workshop*, *Mixed Media Revolution* and *Alternative Art Surfaces*. **Follow Darlene's adventures at DarleneOliviaMcElroy.com.**

DEDICATION:

I couldn't have a better friend and coauthor than Patricia Chapman (yeh, Pat!) or more wonderfully supportive husband, Dave. You both make life sparkle.

ACKNOWLEDGMENTS:

The F+W support team holds us together, makes us look great and are a party to be with—Tonia Jenny, Kristin Conlin, Christine Polomsky and Jamie Markle.

PATRICIA CHAPMAN

Patricia was born and raised in the Midwest with a burning desire to grow up to be a cowgirl. But from the first time she got her hands on a hunk of Play-Doh, the call to create art became stronger than her cowgirl dreams. Patricia studied at the San Francisco Academy of Art and at Arizona University and spent several years out of college creating large-scale fiber sculpture commissions for public and private spaces. Eventually her passion to collect unusual objects led her to the realization that these objects could be mined for their metaphorical content and utilized to make assemblage sculptures combined with text and a large measure of humor to create stories about life, love and other impossible situations. Patricia has shown her art in galleries nationally and internationally and in several publications, and she was featured in the PBS documentary series *In Context*. She lives in Boulder, Colorado, and spends a ridiculous amount of time every day in her studio, teaches both private lessons and workshops, and enjoys a stunningly excellent circle of friends and family. **See what Patricia is up to now. Visit ThePatStudio.com.**

DEDICATION:

To my eternally supportive, encouraging and magnificent family and stellar circle of friends. And to my cat Zoe, who always reminds me to take a break and play with the cat.

ACKNOWLEDGMENTS:

I am forever grateful to my supremely talented coauthor, Darlene. And my deepest thanks to the F+W dream team of Kristy Conlin, managing editor, and Christine Polomsky, photographer. You both made the education of this book newbie so incredibly easy and FUN.

MIXED MEDIA IN CLAY. Copyright © 2016 by Darlene Olivia McElroy and Patricia Chapman. Manufactured in China. All rights reserved. No part of this book may be reproduced in any form or by any electronic or mechanical means including information storage and retrieval systems without permission in writing from the publisher, except by a reviewer who may quote brief passages in a review. Published by North Light Books, an imprint of F+W Media, Inc., 10151 Carver Road, Suite 200, Blue Ash, Ohio, 45242. (800) 289-0963. First Edition.

a content + ecommerce company

Other fine North Light Books are available from your favorite bookstore, art supply store or online supplier. Visit our website at fwcommunity.com.

20 19 18 17 16 5 4 3 2 1

DISTRIBUTED IN CANADA BY FRASER DIRECT
100 Armstrong Avenue
Georgetown, ON, Canada L7G 5S4
Tel: (905) 877-4411

DISTRIBUTED IN THE U.K. AND EUROPE
BY F&W MEDIA INTERNATIONAL LTD
Brunel House, Forde Close, Newton Abbot, TQ12 4PU, UK
Tel: (+44) 1626 323200, Fax: (+44) 1626 323319
Email: enquiries@fwmedia.com

DISTRIBUTED IN AUSTRALIA BY CAPRICORN LINK
P.O. Box 704, S. Windsor NSW, 2756 Australia
Tel: (02) 4560-1600; Fax: (02) 4577 5288
Email: books@capricornlink.com.au

ISBN-13: 978-1-4403-4003-1
ISBN-10: 1-4403-4003-X

Edited by Kristy Conlin and Stefanie Laufersweiler
Designed by Brianna Scharstein
Production coordinated by Jennifer Bass
Photography by Christine Polomsky

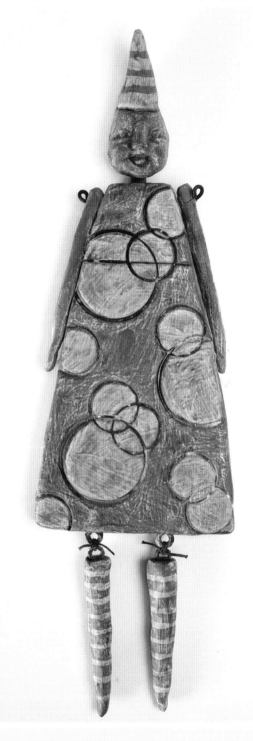

BUBBLES ▪ PATRICIA CHAPMAN
Stamped and painted critter clay slab, with molded and hand-modeled Critter Clay pieces.

METRIC CONVERSION CHART

CONVERT	TO	MULTIPLY BY
Inches	Centimeters	2.54
Centimeters	Inches	0.4
Feet	Centimeters	30.5
Centimeters	Feet	0.03
Yards	Meters	0.9
Meters	Yards	1.1

LOOKING FOR MORE INSPIRATION?

We have tons of FREE *Mixed Media in Clay* bonuses to inspire you!

Just go to createmixedmedia.com/mixed-media-in-clay for access to bonus demonstrations, tips , ideas and art!

Get your art in print!

Visit **ArtistsNetwork.com/ splashwatercolor** for up-to-date information on *Splash* and other North Light competitions.